PARADISE

PICTURING THE GENETIC REVOLUTION NOW

MARVIN HEIFERMAN and CAROLE KISMARIC

with essays by MIKE FORTUN,
FRANK MOORE, RICKI LEWIS, and BERNARD POSSIDENTE
edited by IAN BERRY

HEATHER ACKROYD AND DAN HARVEY
ACTION TANK FOR ®™ARK
SUZANNE ANKER
DENNIS ASHBAUGH

AZIZ + CUCHER DAVID KREMERS

BRANDON BALLENGÉE JANE LACKEY

CHRISTINE BORLAND JULIAN LAVERDIERE

NANCY BURSON AND DAVID KRAMLICH IÑIGO MANGLANO-OVALLE

HELEN CHADWICK KARL S. MIHAIL AND TRAN T. KIM-TRANG

KEVIN CLARKE LARRY MILLER

KEITH COTTINGHAM STEVE MILLER

BRYAN CROCKETT FRANK MOORE

HANS DANUSER ALEXIS ROCKMAN

CHRISTINE DAVIS BRADLEY RUBINSTEIN

MARK DION NICOLAS RULE

GEORGE GESSERT CHRISTY RUPP

REBECCA HOWLAND GARY SCHNEIDER

NATALIE JEREMIJENKO LAURA STEIN

RONALD JONES EVA SUTTON

EDUARDO KAC CATHERINE WAGNER

CARRIE MAE WEEMS

GAIL WIGHT

JANET ZWEIG AND LAURA BERGMAN

CONTENTS

It was only fifteen months ago, in June 2000, that the media heralded the riveting news of the sequencing of the human genome. As Dr. Francis Collins, director of the National Human Genome Research Institute, and Dr. Craig Venter, president and chief scientific officer of Celera Genomics Corporation, shook hands and posed with the president in the White House Rose Garden, the closely watched race to crack the genetic code appeared to have ended in a tie. The exhilaration and photo opportunity of that moment briefly overshadowed the intense

INTRODUCTION

and ongoing competition between a consortium of not-for-profit institutions and a publicly traded corporation, each determined to claim a victory and to reap the future benefits of genetic research.

To many people watching that evening's television coverage or reading the next morning's headlines, genetics had become big news. Earlier, isolated

curiosities—like the first successful cloning of a mammal, Dolly the sheep—no longer seemed so freakish once advances in genetics began to appear regularly in print, on television, and in the science and financial press. For specialists and for the public, a threshold has been reached. All of us are witnessing how unfolding discoveries in the field of genomics—the study of genes and the proteins whose work they initiate and control—are beginning to rewrite the definition of life. THE INFORMATION REVEALED IN THE MAPPING OF THE HUMAN GENOME IS ALREADY HAVING WIDESPREAD AND UNIMAGINABLE IMPLICATIONS—in science, medicine, agriculture, business, and the law. And because of these changes, our understanding of health, social organization, race, aesthetics, and spirituality is being profoundly challenged. With so much at stake, the need to take stock of where we are, and where we might be

going, is crucial. With all sorts of compounded pressures to move forward—to cure disease, extend life, modify cells and plants and animals, bolster agricultural productivity, and to make ourselves and our world more "perfect"—it is time to pause and to reflect on WHAT KIND OF "PARADISE" ARE WE RUSHING TOWARD NOW. Who will be responsible for what these changes will bring? What are the important issues and concerns that need to be raised? Whose voices need to be heard and heeded?

Paradise Now: Picturing the Genetic Revolution was conceived to encourage the public to take a more active role in the ongoing dialogue that will shape our future. As the exhibition's curators, we wondered whether a show of provocative artworks might help viewers engage in ideas and issues that are too often dismissed as complex when encountered in print, or as too vague when they are glossed over in a few seconds of fleeting images and narration on television.

To find artists who were serious about tackling the questions genetic research provokes, we consulted with artists, scientists, and with other curators and reviewed the work of nearly two hundred artists. The thirty-nine people who were selected reflect a broad range of perspectives, media, and concerns. Until recently, many have worked independently, some for more than a decade, unaware that so many other artists were exploring ideas about genomics. WHAT DRAWS THESE ARTISTS' WORKS TOGETHER IS A SHARED ENGAGEMENT WITH SCIENCE, A SENSE OF AUTHORITY, AND THE WILLINGNESS TO TAKE ON AND TO COMMUNICATE COMPLEX ISSUES AND IDEAS.

While a number of exhibitions in recent years have loosely explored the relationship between art and science, *Paradise Now* is the first to specifically focus on genetics as a subject for artists. Some of the works in this exhibition are strikingly iconic, deploy-

ing literal images of genetic material itself to question our most basic assumptions about the definition and meaning of life. Other artists follow their curiosity into the controversial areas of genetic research and commerce. The artists in *Paradise Now* come to the subject with diverse backgrounds and experiences. Some have trained in the sciences and a number have current institutional affiliations. Others have sought out scientists and researchers as advisors, and, in some instances, have worked in active collaboration with them.

Most of the work in the exhibition has been made outside of the sanctioned interests of the mainstream art world, and as a result has been marginalized as much by its seriousness and specificity as by its subject matter. But the issues about which these artists make art are now central to the world at large. The timeliness of *Paradise Now* is intentional, meant to further stimulate discussion as science introduces

radical perspectives and new pathways to under-standing human experience. GENETICS GIVES ARTISTS THE ROOM, FOR EXAMPLE, TO QUESTION NOT ONLY MORTALITY, BUT TO SPECULATE ON THE MORAL, SPIRITUAL, LEGAL, AND AESTHETIC ISSUES THAT GO BEYOND LIFE AND DEATH TO EMBRACE NOTIONS OF IMMORTALITY.

In addition, the images and interactive works in *Paradise Now* help scientists better communicate the nature and importance of their work to a public more often comfortable with images than with words.

Working with the language and images of sci-ence—and sometimes stretching the traditions, con-ventions, and subject matter of art—artists in *Paradise Now* provide exhibition visitors with an opportunity to consider the impact and implications of genetic research in their lives. Ironically, while works in the show make frequent use of unconven-

tional materials (including cancer cells, body fluids, live animals, cloned plants, DNA, and even custom-designed bacteria), media, and imagery, they often fall into conventional art categories: portraits, still lifes, and landscapes. Approximately half of the artists explore how recent discoveries in genetics are changing and reshaping our conception and under-standing of identity and individuality. Several of these works, for example, examine the extent to which the genetic revolution forces us to rethink the social, cul-tural, and scientific definitions of race. Other artists speculate about what motivates increasingly aggres-sive intervention in what once were understood to be the "natural" processes that defined life and death. In the end, much of the work in *Paradise Now* questions what genetic research is revealing about us, individu-ally and collectively. Why are we so compelled to con-trol our bodies, our lives, and our fate? HOW MIGHT OUR THINKING, BEHAVIORS, AND VALUES SHIFT, AS SCIENCE AND TECHNOLOGY

TRANSFORM WHAT WE'VE HAVE TAKEN FOR GRANTED FOR SO LONG?

Other artists in the exhibition consider the reasons, mechanics, and frequency with which genetics is used to shape nature to conform to human demands. Our environment has, for centuries, been willfully shaped and reshaped to meet our needs. The foods we eat, the animals and plants we breed have long been genetically manipulated and monitored with an eye towards enhanced size, efficiency, and productivity. But, with greater understanding of, and a heightened ability to alter biochemical processes and events, researchers, farmers, and agribusiness executives will ultimately have the capability to tip what has been romantically referred to as the balance of man and nature. Many of the artists in *Paradise Now* question what kinds of motivation might account for the increasingly aggressive genetic modification of crops, animals, plants, and the foods we produce and eat.

While artists and scientists may be quick to accept the complexity of their idiosyncratic voyages of discovery, visitors to *Paradise Now* most likely need guidance in understanding the ideas the inform the works on exhibit. Since we want to stimulate serious thinking about the relationship of art to science, and more specifically about the implication of genetics in our everyday lives, we decided to deliver information that would aid visitors in interacting with the art. To that end, the installation includes examples of objects and images from popular culture—such as film posters, bumper stickers, graphs, cartoons, and product packaging—that REVEAL HOW OUR HOPES, FANTASIES, AND FEARS ABOUT GENETICS HAVE ALREADY BECOME A PART OF PUBLIC DISCOURSE AND OUR CULTURAL LANDSCAPE. Also on display are scientific images, apparatus, and objects—maps that locate specific genes on chromosomes, gene

chips, and genetically modified foods—that add information and texture to experiencing the works of art. Because decoding contemporary art can be as complicated as uncovering the mysteries of genomic, each artist was asked to write a statement that might help exhibition visitors understand how and why genetics captured their interest and imagination.

Finally, *Paradise Now* surprisingly reveals similarities in the goals and the working methods of artists and scientists. In each discipline, individuals follow their curiosity by developing systems of inquiry that define the path of their experimentation. Scientists and artists alike work toward defining meaning and discerning the relationships that can be extracted from the rich and often chaotic barrage of facts, images, and impressions that they observe and investigate. Each is, perhaps, more accepting of accident than most individuals, aware that startling avenues of possibility often arise from uncertainty.

And, WHEN ARTISTS AND SCIENTISTS REVEAL SOMETHING PREVIOUSLY UNKNOWN OR UNSEEN, OR BRING INTO BEING SOMETHING THAT DID NOT EXIST, THEY ARE, IN ESSENCE, CREATING SOMETHING NEW. A scientist's work may have a direct and practical application; an artist's goal might be more subjective, and some might argue, not as practical. But, what unites a scientist, whose genetic research helps detect cancer before it becomes a threat, with an artist whose work provides insight into what it means to be alive, is very real. Each searches for truths that contribute to the quality and understanding of our lives; each seeks to make at least some of the mysteries of life more comprehensible and, perhaps, less overwhelming.

MARVIN HEIFERMAN CAROLE KISMARIC

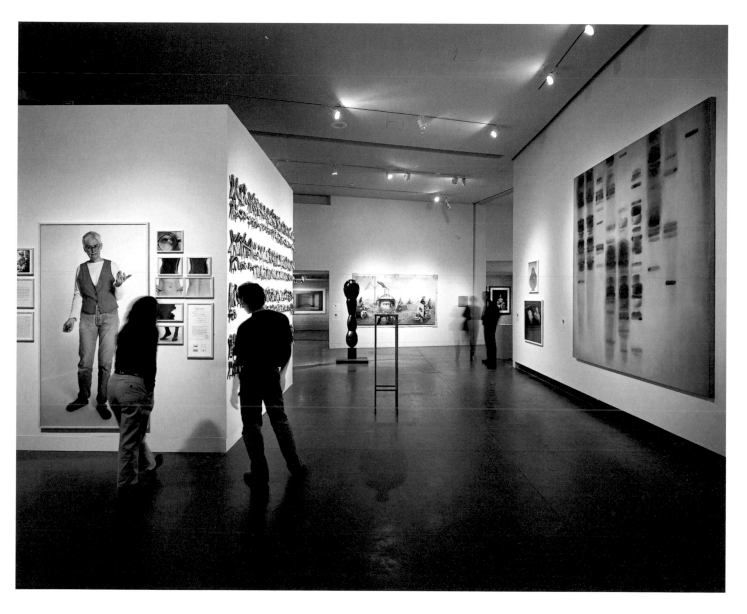

Installation view
Tang Teaching Museum, Skidmore College,
Saratoga Springs, New York

MIKE FORTUN

NOW THEN: PROMISING SPEED GENOMICS

Now?

Paradise Now? What if, when it comes to genomics, there is no *now* now? What if, in our accelerated time of accelerated techno-science, paradise and other promised lands are better thought of as just that—promised? Anticipated, deferred, hoped for, committed to, sworn by, hotly desired—but never *now*. And yet—still—here with us in its half-presence. What would it mean to live in a genetic "now" so rendered by speed that it already becomes—but only and ever becomes—the future?

Warp, Drive

"The Human Genome Project has just entered warp speed."[1] So began an article in the March 1999 issue of *Science*, describing a new effort by a recombinant public/private consortium to produce at least a "first draft," ninety-percent-complete sequence of the human genome by March 2000—approximately five years ahead of original projected timetables. The consortium was organized by the U.S. National Institutes of Health's National Human Genome Research Institute (NHGRI) and Britain's Wellcome Trust, but was funded largely by such pharmaceutical companies as Bayer, Novartis, Glaxo Wellcome, Pfizer, Roche, and SmithKline Beecham. The new quasi-public, semi-private effort responded to corporate high-speed sequencing initiatives being undertaken by companies like Celera

Genomics and Human Genome Sciences, and the likelihood that much of the sequence-based information being produced in these new genomics companies would be tied up in patents, copyrights, licenses, or other forms of proprietary intellectual property.

A year of intense work and equally intense argument followed. Celera President Craig Venter and NHGRI Director Francis Collins became minor media figures as they argued publicly (and privately) over issues of genetic data access and ownership while the two "sides"—call them Capital and State, for old times' sake—apparently raced for the finish line of the complete human genome sequence. A media-fueled technodrama. Finally, on June 26, 2000, a symbolic end was orchestrated as Venter and Collins appeared on either side of President Bill Clinton at a White House press conference, with Prime Minister Tony Blair beaming via videolink, to announce that "the" human genome had been completely sequenced *now*. (The sequence wasn't really completed, for those accuracy fetishists out there, but that need not spoil the party.) State and Capital in the state capital, apparently happily married through genomics.

In the accelerated worlds of genomics, the public/private distinction isn't the only thing to blur and smudge. As any science fiction fan will tell you, when large technoscientific machines enter warp speed, time itself is likely to be distorted—dilated, looped, forked, wormholed, or otherwise warped. Intrepid scientists encounter previous versions of themselves or alternate histories altogether, and causality and change no longer seem to operate unidirectionally. *Time* magazine announces "Drugs of the Future" on its cover *now*—but you'll have to wait...

Time, then, to re-read some of the early history of the Human Genome Project. Now that genomics is apparently shuddering under the force of its own warp drives, these stories might be pored over for signs of other kinds of history, other kinds of time, and causal chains other than the straight ones that we generally take for granted. Only through establishing some kind of rapport—however tentative, experimental, and counterintuitive—with the un-timeliness of genomics will we be able to respond better to its overwhelming scientific, social, and ethical complexity. Because if there's one thing that organisms, genomics, and history have in common, it's this: they're always out ahead of themselves. Every life form, every life science, every story about them: less *now*, more *now then*. Not present, so much as promised: *just you wait*. Not an easy situation to be in, but by familiarizing ourselves with the various ways in which "the future" is called up in our biology *now*, we may arrive at some better appreciation of how the future's warp has

already been woven into our science and our lives now.

Speed Stick

fast[1] (f?st) *adj.* fast·er, fast·est. 1. Acting, moving, or capable of acting or moving quickly; swift. 2. Accomplished in relatively little time: *a fast visit.* 3. Indicating a time somewhat ahead of the actual time: *The clock is fast.* 4. Adapted to or suitable for rapid movement: *a fast running track.* 5. Designed for or compatible with a short exposure time: *fast film.* 6.a. Disposed to dissipation; wild: *ran with a fast crowd.* b. Flouting conventional moral standards; sexually promiscuous...

 7. Resistant, as to destruction or fading: *fast colors.* 8. Firmly fixed or fastened: *a fast grip.* 9. Fixed firmly in place; secure: *shutters that are fast against the rain.* 10. Firm in loyalty: *fast friends.* 11. Lasting; permanent: *fast rules and regulations.* 12. Deep; sound: *in a fast sleep.* (American Heritage Dictionary)

Rush Order

Quickly now: *the Human Genome Project never existed.*

A bit more slowly: the "Human Genome Project" was a convenient marker that could be bound to the huge writhing mass of accelerating genetic research already happening at federal and university labs in the1980s. Tagged like this, members of Congress, journalists, you and I could all *see* it—and *get behind it* with our money and enthusiasm. There was no single motive for further accelerating an already quick scientific field: curiosity and the desire for knowledge synergized with promises of profitable new technologies, and many other forces as well.

 Consider James Watson, whose entire career may be said to have been founded on the superior velocity that he and Francis Crick showed in the 1953 "race" for the double helix. Prior to becoming the first director of the National Center for Human Genome Research, Watson was instrumental in speeding up genomics in the 1980s through his advocacy for an enlarged, accelerated, and independent government funding mechanism with the catchy name and convenient three-letter acronym, HGP. Faster to him was not only better, it was more moral. "If you want to understand Alzheimer's disease," he told a journalist in 1990, "then I'd say you better sequence chromosome 21 as fast as possible. And it's unethical and irresponsible *not* to do it as fast as possible".[2] Or as he put it to a U.S. Senate committee in 1990:

Some people say, well, why this targeted project, why the hurry? Why not just let the individual investigator (R01) grants come in, and not have this big program. I think if you are a family with a serious genetic disease, you know, there are only a certain number of years you are going to live. You do not want that gene to be found 100 years after you are

dead. So, if we can do this work over the next five years, I think we should do it...I think we are doing the moral thing to try hard to get these genetic resources...if you can find it now, I would rather have it this year instead of ten years from now. So I am in a hurry.[3]

To this linking of medical and moral imperatives, we should add personal motivations. Watson has mused upon his own mortality in addition to that of people from families with serious genetic diseases, placing those musings within the narrative demands of his life and career:

> People ask why *I* want to get the human genome. Some suggest that the reason is that it would be a wonderful end to my career...That *is* a good story...The younger scientists can work on their grants until they are bored and still get the genome before they die. But to me it is crucial that we get the human genome now rather than twenty years from now, because I might be dead then and I don't want to miss out on learning how life works.[4]

Race to NowHere

Long before he founded and became president of Celera Genomics, J. Craig Venter had appreciated the real goal and underlying logic of the Human Genome Project: not so much to fully sequence the genomes of humans and other organisms, but to create an infrastructure of faster, more efficient genomic technologies that would inject new power into the engines of the biotechnology industry. The desire and need for "the whole thing" was always secondary to radically improved technological capacity for the production and analysis of genomes and the organisms with which they were webbed.

In 1987 Charles DeLisi, an early and strong advocate of the HGP and at that time in the U.S. Department of Energy, testified to a U.S. Senate committee that the goal of the HGP was "to develop technologies that would make sequencing...a lot quicker than it currently is...[I]f you want to sequence a hundred thousand bases [in] twenty people and compare their sequences and understand disease susceptibilities, you can't do that, it's not a clinically viable procedure. We can make that a clinically viable procedure. That's the goal, it's not to sequence the human genome, at least initially." At the same time Johnson & Johnson Corporation's Jack McConnell, who helped draft early U.S. legislation on the HGP, testified:

> If we want the U.S. to maintain its position as a dominant force in the pharmaceutical industry in the world, I cannot imagine our letting this opportunity pass us by...[T]he group that first gains access to the information from mapping and sequencing the human genome will be in position to dominate the pharmaceutical and biotech industry for decades to come.[5]

Venter's "race" with the "public" HGP made great copy; the story is even true. But it's also true that Celera and the rest of the genomics industry only intensified and extended some of the original rationales for the HGP: to build the infrastructure of tools, techniques, biosubstances, and biodata to compete in, if not dominate, a global bioeconomy. Leroy Hood, co-inventor of the automated DNA sequencer, always emphasized not the final goal but the "fantastic infrastructure": the largely automated, high-throughput tools and techniques of genomics created through the HGP. Mathematician-turned-leading-genomicist Eric Lander once called this infrastructure the "Route One of Genetics," a name which better conjures up the promise of high-speed movement, destined travel, or sheer flight. I'd also advance a different metaphor: the HGP was created to create the technological and economic conditions so genomics companies like Celera could be born and grow up to outpace and annoy their parent, the federal patron who— sigh—had given them such advantages in life...

Fastening Truths to Organisms

"Like other sciences, biology today has lost many of its illusions. It is no longer seeking for truth. It is building its own truth. Reality is seen as an ever-unstable equilibrium."

— François Jacob, *The Logic of Life*

The Nobel laureate, eminent biologist, and fine writer François Jacob understands the energetic vibrations in organisms and in our conceptualizations of them—and how those conceptualizations are themselves a vibratory effect of whatever laboratory, social, and linguistic technologies are being used in the building of the biological truths of any given moment. If an organism is an "ever-unstable equilibrium," what are organisms becoming within the "fantastic infrastructure" of genomics? What truths are being built into and out of organisms *now*?

Genetic determinism or *reductionism* is the too-hasty answer—that genomics is reinforcing the "it's all in your genes" view of life and illness. And even if everyone from biotech critic Jeremy Rifkin to genome enthusiast Francis Collins now hurries to dismiss simplistic and deterministic notions of genetic causality, such oversimplifications nevertheless persist as built truths, stable equilibria. Open a newspaper or magazine, surf over to your favorite web site, tune in the *Discover* channel, and you can easily find a story in which genes *cause* a disease, a behavior, a talent, a temperament. Or, in a more vague formulation that still somehow manages to satisfy, genes are said to produce a propensity, a capacity, a predilection, or a predisposition for such traits. But the message is still clear: nothing is more creative or more fundamental than the gene,

otherwise known as "the secret of life."

But it may be that one of the greatest gifts of the relentless high-speed technological chase of the gene and the fundamental power it seems to contain will be its own conceptual undoing: "the gene" may become a different unstable equilibrium, and we will come to know a different truth about organisms like us. Genomics promises to unravel simple genetic causaility and determinism.

Evelyn Fox Keller's recent book, *The Century of the Gene*, details the seemingly paradoxical development in which, "at the very moment in which gene-talk has come to so powerfully dominate our biological discourse, the prowess of new analytic techniques in molecular biology and the sheer weight of the findings they have enabled have brought the concept of the gene to the verge of collapse." It is a conceptual collapse caused by the sheer weight of new genetic sequence information and other kinds of information. Keller quotes molecular geneticist William Gelbart who, in his 1998 article in *Science* titled "Databases in genomic research," argued that the gene may be "a concept past its time;" the "historic baggage" which the concept has accumulated may have to be shed, since "we may well have come to the point where the use of the term 'gene'...might in fact be a hindrance to our understanding."[6]

If the twentieth century was indeed *The Century of the Gene*, then the twenty-first is shaping up to be The Time of the Ome. The –ome has become a necessary supplement to the gene, and now to a host of other entities as well. In the 1980s it became no longer sufficient to study a gene or genes, but to go after the entire *genome*. Life scientists who were once enmeshed in the processes of single gene expression and the ways in which a piece of DNA was written into messenger—and transfer—RNA now have interested themselves in the *transcriptome*, the tome that covers all of an organism's capacities for expression. And increasingly, now that the human genome has been more or less completely mapped and sequenced and uploaded into multiple distributed databases—open, proprietary, and interesting new hybrids of open and proprietary databases— and now that it seems increasingly clear that there are simply not enough genes to fully account for the complexity of the human organism, the interests and hopes of scientists and investors alike are beginning to shift to the *proteome* and proteomics, the study of all the proteins produced by an organism. The scientific and social promise that genomics held almost exclusively just ten years ago may *now* be shifting, as "the gene" becomes destabilized; the most promising science *now* is often summed up under the heading of "systems biology"—although no one is quite sure what "systems biology" means or entails.

And let me quickly remind you: no one is

quite sure when *now* is. The concept of "the gene" is not so much collapsing *now* but, in Keller's phrasing of it, is only "on the verge" of collapse. The *now* overlooks a promised land, a future paradise which it abuts and sees or at least envisions, but which the *now* is now denied. And history gives us precious few reasons to think that we will ever cross.

Continual withdrawal of truth. Or as Craig Venter recently put it, "My view of biology is, 'we don't know shit'."[7] Surely ten years and $3 billion is a small price to pay for a reminder that biological truths are ever-unstable equilibria, ever-limited, ever-temporary.

We're always on the verge of knowing what we're doing.

Promises, Promises

Fine, then. Like any other experimental endeavor, genomics is not only *about* promises—better drugs, better food, better you – but genomics *is* promising. Genomics is a science and an industry that works by speculating in, gambling with, betting on, or otherwise *leveraging* limited knowledge, incomplete information, and a network of diverse resources into a promised future. Forget the grand stories about races and "the Book of Life" and complete truths and "the secret of being human." Promises, promises. But keep your eyes on the tools, the practices, where data flows and where it is tied up, the conditions under which blood is drawn and tissue frozen and bioinformation extracted. This is the genomics infrastructure for promising, for making something out of nothing. Keep in mind, though, that in this promissory economy of promising techniques and promising organisms, there are no hard and fast rules for telling the legitimate promise from the potential swindle and con. Keep in mind that we are dealing with a multitude of ever-unstable equilibria—diseases, personal ambitions, genuine concerns for well-being, the needs of capital and capitols, intricately folded molecules, and the truths and the bodies and the selves we like to call "ours"—and they each have, for lack of a better term, a life of their own that is, like all life, excessive. Life on the verge of genomics, so full of promise, is unnerving *and* exhilirating.

Promises, promises. The colloquialism locates the always doubled and usually even more multiple qualities of the promise. And like the famous doubled "yeah, yeah" which rattles the affirmation of truth statements even as it performs it, "promises, promises" sets up the skepticism that should rightfully inhere to the simultaneously admirable, commendable, and unavoidable event of the promise.

So if you find yourself too comfortable in either a cheery enthusiasm or a dour apocalypticism, keep returning to these art pieces in *Paradise Now*. They may destabilize your equilibrium. Here are, not artists of paradise now, but artists of the genomic verge.

Here are verge artists that swerve our understandings and imaginations of genes, organisms, and their worlds, provoking encounters with the uncertainties on which the promise hinges.

Eduardo Kac's "Genesis," for example, instantiates the Human Genome Project's true message—projects it, even the genome is a text only by virtue of being assembled with other texts; it codes only by having always already been coded. Or, as genomicists Ognjenka Vukmirovic and Shirley Tilghman wrote recently in *Nature Biotechnology*: "Organisms are networks of genes, which make networks of proteins, which regulate genes, and so on *ad infinitum*."[8]) A genesis with no end, a promise that arrives at no paradise *now*, but only promises its own continued promising. And a paradise whose promise is (thank g-d!) continually disrupted by chance, the cosmic throw of a pair o' dice. That's what genes is.

All too fast. All too sketchy. You'll need to draw it out.

Move It, Now!

"There are too many complaints about society having to move too fast to keep up with the machine. There is great advantage in moving fast if you move completely, if social, educational, and recreational changes keep pace."

— Margaret Mead, quoted in *Time*, September 4, 1954.

1. ELIZABETH PENNISI, "ACADEMIC SEQUENCERS CHALLENGE CELERA IN A SPRINT TO THE FINISH," SCIENCE 283 (19 MARCH 1990), 1822.

2. QUOTED IN STEPHEN S. HALL, "JAMES WATSON AND THE SEARCH FOR BIOLOGY'S 'HOLY GRAIL'," SMITHSONIAN (FEBRUARY 1990), PP. 41–49, ON P. 46.

3. U.S. SENATE, THE HUMAN GENOME PROJECT, SUBCOMMITTEE ON ENERGY RESEARCH AND DEVELOPMENT, COMMITTEE ON ENERGY AND NATURAL RESOURCES, JULY 11, 1990. (101ST CONGRESS, 1ST SESSION, S. HRG. 101–894)

4. JAMES D. WATSON, "A PERSONAL VIEW OF THE PROJECT," IN THE CODE OF CODES: SCIENTIFIC AND SOCIAL ISSUES IN THE HUMAN GENOME PROJECT, ED. DANIEL J. KEVLES AND LEROY HOOD (CAMBRIDGE: HARVARD UNIVERSITY PRESS, 1992), PP. 164–173, ON PP. 164–165.

5. U.S. SENATE, DEPARTMENT OF ENERGY NATIONAL LABORATORY COOPERATIVE RESEARCH INITIATIVES ACT, SUBCOMMITTEE ON ENERGY RESEARCH AND DEVELOPMENT, COMMITTEE ON ENERGY AND NATURAL RESOURCES. SEPTEMBER 15 & 17, 1987. (100TH CONGRESS, 1ST SESSION, S. HRG. 100–602)

6. WILLIAM GELBART, "DATABASES IN GENOMIC RESEARCH," SCIENCE 282 (1998), P. 660, AS QUOTED IN EVELYN FOX KELLER, THE CENTURY OF THE GENE (CAMBRIDGE: HARVARD UNIVERSITY PRESS, 2000), P. 68.

7. QUOTED IN RICHARD PRESTON, "THE GENOME WARRIOR," THE NEW YORKER, JUNE 12, 2000, PP. 66–83.

8. OGNJENKA GOGA VUKMIROVIC AND SHIRLEY M. TILGHMAN, "EXPLORING GENOME SPACE," NATURE BIOTECHNOLOGY 405 (2000), PP. 820–822.

SOMETHING'S COMING

Something's coming
I don't know what it is
But it is going to be great...
Around the corner, or whistling down the river,
Come on, deliver, to me.
—West Side Story

We've arrived at the fountainhead of life—DNA—and we're all over it, like ants on watermelon at a summer picnic. Swarming, each with our own agenda—artists, scientists, politicians, educators, philosophers, you name it: It's Happy Hour. Everyone staking out their own turf, filing patents for gene sequences, creating new artistic genres like the "genetic portrait," mining the rain forest for genetic material, developing new forensic methods for criminal investigations or anthropological research. It's a gold rush, which continues in spite of the ups and downs of biotech stocks. It would be nice if there were some life form around that was not DNA (or RNA) based to put this into perspective, but no luck; it's the only game in town. What makes it so sweet, so obsessively attractive?

What do we know? For all the hoopla, which accompanied the millennial announcement that the human genome had been decoded, you might think that the game was over. But then the hedging began to leak out: we haven't decoded "junk" DNA (which Eric Lander at MIT thinks is a misnomer).[1] We

haven't decoded the "centromeres," the areas where chromosomes join.[2] William Haseltine, CEO of Human Genome Sciences says there are 100 thousand genes; Craig Venter, President of Celera, says there are only 30 thousand.[3] And then having the sequence for a protein turns out to be a bit like having a pile of thread from and unraveled Balenciaga. It's all there, but can somebody please put it together?

Enter a new field—proteomics. In collaboration with MDS Proteomics, IBM has created a whole new offshoot of supercomputers to decipher the protein structures encoded by our genes.[4] We're zeroing in.

Already many life-enhancing, even life saving, genetically engineered products have come to market. I myself, an artist who has been living with HIV/AIDS for almost two decades, am alive today in part because of recombinant DNA medications, which helped me through life-threatening illness. Yet in spite of the excitement and the astounding advances reported almost daily in newspapers across the country and indeed around the world, there seems to be a background sense of unease. At times it seems like we're heading down a bad road that we've already been down way too many times before. Nuclear power, asbestos, DDT and Agent Orange were all much-heralded scientific advances created to benefit humanity but they wound up as lethal headaches, spawning massive grassroots resistance that continues to this day. At time it seems that this resistance is only too ready to latch onto the next demon target, which in this case may be genetic engineering.

It hasn't helped that a major player like Monsanto (which was already singed by lawsuits stemming from its production of Agent Orange) made major miscalculations in choosing its first products to bring to market. Genetically engineered Bovine Growth Hormone raised fears that children drinking milk might be affected, and genetically modified (GMO) corn which was engineered to produce its own pesticide raised fears both for the consumer and for Monarch Butter-flies which in field trials died from eating corn pollen (those bones you hear rattling in the background are Rachel Carson's).[5]

Monsanto has since backpedaled and become Monsanto-Clause, decoding the rice genome and doing other good works in the biotech arena, but the essential tension remains: genetically engineered products released into the environment are creating a very bad vibe.[6]

This is just a sketch of the context in which new art referencing genetics is emerging. It is a very fluid moment, an astounding moment, a very delicate moment, and artists are already playing a role in visualiz-

ing these issues and influencing their reception by the public.

Artists have long played a role in presenting new discoveries to the public and indeed, in influencing public policy. Well over a century ago images of the Yellowstone by painter Thomas Moran and photographer William Henry Jackson were shown to Congress and played a key role in the establishment of America's first National Park.[7] A large and celebrated painting of Niagara Falls by Frederick Church was brought before Queen Victoria and the English Parliament: this lent vital momentum to the effort to win English approval for the creation of a Canadian-American partnership to preserve the Falls as a public resource. These paintings and photographs "nucleated" public support. In precisely the opposite fashion, widely circulated photographs taken in 1987 of scientists, completely enveloped in decontamination suits, spraying strawberry fields in California with genetically engineered "ice minus" bacteria effectively "denucleated" support for genetically modified agricultural products.[8]

Strong images, whether created by painters, photographers, sculptors, video artists or filmmakers tend to acquire a life of their own. They may influence public discourse in countless, often untraceable, ways. It is critically important to pay attention, not just to the advances in genetics, but to their visual representation and interpretation by artists.

Like GMO corn, genetically modified art is wind pollinated. The ideas em-bodied in the works included in *Paradise Now* include just a fraction of the new concepts (pollen) blowing about in the press, on radio and TV, on the Internet, anywhere the rubber of science hits the road of the popular imagination. And just as the corn grown in the USA represents a limited number of select and heavily promoted strains, so too the works in *Paradise Now* tend to focus on areas heavily promoted by the media. Cloning, the environmental implications of biotechnology, and the genetics of race are all explored here, but the artists often imbue these concepts with a distinctive emotional charge or expose unexpected implications.

This art may seem fanciful; its relevance to our daily life may seem tangential at best, but its significance should not be underestimated. **Each of the artists in *Paradise Now* is presenting the visual tip of a submerged iceberg of information:** each is crystallizing countless hours of discussion with peers and others, including scientists. Each has been immersed in the media representation of this revolution, and each has spent endless hours of reflection and experimentation, evolving their individual visual

response. If one thing is clear from this exhibition, it is that one can no longer think of this as simply a revolution in genetic science. These works illuminate contingent transformations underway in religion, agriculture, art, education, criminal justice, history, anthropology, animal husbandry, politics, medicine, even in the ways we define ourselves as human.

This illumination carries with it a critical and ethical perspective, which in some works amounts to a plangent appeal to viewers to wake up and smell the GMO coffee. The majority of works however are more guarded in their assessment of the changes in store for us all, urging a heightened awareness if only by their very strangeness. Viewers who key into the intense curiosity and excitement these artists channel into their works may well sense that "The air is humming/And something great is coming./ Who knows?"[9]

1. REMARKS DELIVERED AT THE PRESS PREVIEW OF PARADISE NOW: PICTURING THE GENETIC REVOLUTION, EXIT ART, NEW YORK, SEPTEMBER, 2000.

2. "THE JUNK DNA THAT ISN'T GARBAGE," *THE NEW YORK TIMES*, TUESDAY, FEBRUARY 13, SCIENCE TIMES, P. F5.

3. "DOUBLE HELIX WITH A TWIST—DO FEWER GENES TRANSLATE INTO FEWER DOLLARS?" ANDREW POLLACK, *THE NEW YORK TIMES*, TUESDAY, FEBRUARY 13, 2001, BUSINESS DAY, P.1.

4. IBM PRESS ROOM, JANUARY 30, 2001, WEBSITE: HTTP://IBM. COM/PRESS/PRNEWS.NSF /PRINT09AC58C1987270A 7852569

5. "HOW GENETICALLY ENGINEERED FOOD WENT FROM THE LABORATORY TO A DEBACLE," *THE NEW YORK TIMES*, THURSDAY, JANUARY 25, 2001, P. A1.

6. "RICE GENOME DECODED," *THE NEW YORK TIMES*, AGENCE FRANCE PRESSE WIRE SERVICE ITEM, WEDNESDAY, APRIL 5, 2000.

7. "VISIONS OF AMERICA," RON TYLER. THAMES AND HUDSON, 1983, P. 57.

8. IBID, *THE NEW YORK TIMES*, THURSDAY, JANUARY 25, 2001.

9. "SOMETHING'S COMING," LYRICS BY STEPHEN SONDHEIM, FROM WEST SIDE STORY.

We are exploring the capacity of grass to record complex photographic images through the production of chlorophyll. The equivalent of the tonal range in a black-and-white photograph is produced in the yellow and green shades of living grass. Although these organic "photographs" are exhibited in a fresh state for a short time, excessive light or lack of it eventually corrupts the visibility of the image. Our inquiry into how to "fix" these transient images has brought us close involvement with genetics through research with scientists at IGER (Institute of Grassland and Environmental Research) in Wales. These scientists have developed a grass that keeps its green color even under stress. In a naturally occurring variant of grass, they identified a gene for an enzyme that degrades the green pigment chlorophyll, and by modulating the expression of this gene,

HEATHER ACKROYD
AND DAN HARVEY

30

they were able to alter the grass's aging behavior and even stop it altogether. Through a plant breeding program they have intro-

duced this trait, coined a stay-green, into a rye grass. The application of this grass in our work has subsequently led us to grow photographic canvases and then dry them. While the green blades retain their chlorophyll much more effectively than regular grass, the effects of other processes, such as oxidative bleaching, gradually occur and over time contribute to an irreversible loss of image.

The artists' participation in this exhibition is made possible by the support of NESTA (National Endowment of Science, Technology and Art, UK).

Heather Ackroyd & Dan Harvey met in London where they had simultaneous exhibitions of installations using grass. They earned the Sciart award from The Welcome Trust in 1996 and were represented in the seminal exhibition *Out of Sight: Imaging/* *Imagining Science* at the Santa Barbara Museum of Art in California in 1999. They have shown widely throughout Europe and North America at venues such as the Victoria & Albert Museum, London, 2000, the Musee de l'Elysee, Lausanne, 1999, the Santa Barbara Museum of Art, 1998, the Dazibao Gallery, Montreal, 1995, The Palazzo delle Esposizioni, Rome, 1994, and recently installed *Presence*, a new work for the Isabella Stewart Garden Museum's special exhibition gallery in Boston, 2001. Ackroyd and Harvey were awarded the Grand Prize, *Art and Science of Color*, by L'Oreal in 2000.

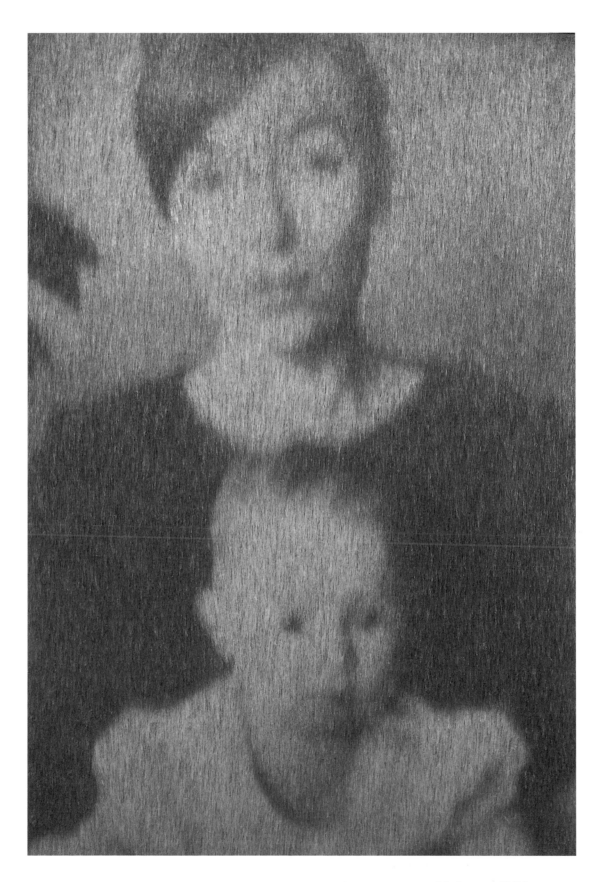

Mother and Child,
2000

®™ark is pleased to announce its newest mutual fund, the Biological Property Fund, managed by Dr. Jacqueline A. Stevens. Projects in this fund highlight the dangers of the high-stakes industry of biotechnology, which promises to improve corporate life while ensuring great risk for human life.

These mutual funds direct public attention to the biotechnology-corporate partnerships scavenging the Third World and the interiors of bodies for valuable genes, without addressing long-term social, health, and environmental consequences of

ACTION TANK
FOR ®™ARK

genetic patents, alterations, and population branding. Projects call attention to how biotechnology is shifting public attention away from corporate responsibility for environmental damage and social inequities and toward genetic essentialism: recoding genes to benefit corporations by "improving" productivity, race, class, and sex. This is a volatile, high-risk fund that promises dramatic short-term and long-term yields.

ACTION TANK is an independent agency that develops cross-over entertainment products to mobilize critical thought and action. Deploying high-leverage technology to reflect changing global realities and to maximize social engagement, **ACTION TANK** loads seemingly innocuous consumer products such as music videos, computer and video games and Microsoft PowerPoint presentations with unexpected ammunition. **ACTION TANK** was founded by Jin Lee and Natalie Bookchin in 2000.

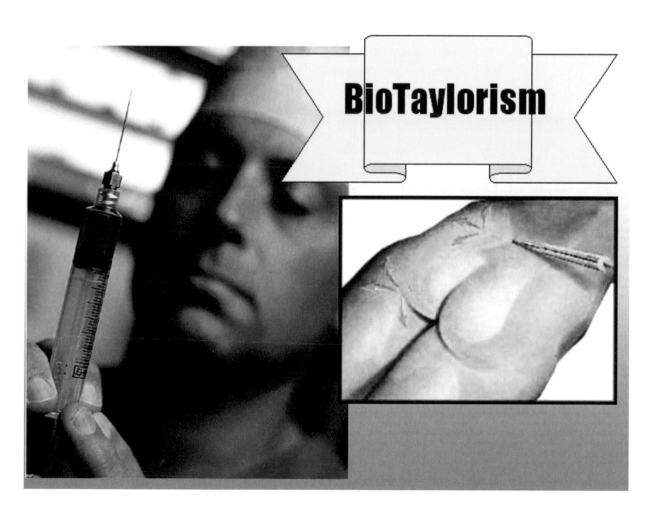

BioTaylorism, 2000

During the late eighties I had been working on a number of sculptural projects that relied on the transformation of ephemeral natural materials—nests, lily pads, volcanic ash-covered eggs—into the more permanent substance of bronze. Foundries are like laboratories; apparatus galore, furnaces reminiscent of alchemical chambers; they are places where transformation and reincarnation are made visible. As part of *Fixed Gaze* (1989), a sculptural installation, I included several kaleidoscopic lenses at-

SUZANNE ANKER

tached to vessels. The viewer was invited to look through the lens, which further replicated the images before him into a spectacular visual experience. The resulting photographs from this instrumentalized visionary process appeared to be microscopic in nature, circularly framed, and intimately revealing. I wondered what other natural forms are ephemeral, hidden, and function in a transformative, replicative way. I had discovered the iconography of chromosomes.

Suzanne Anker is a visual artist and theoretician working with genetic imagery. Her work has been shown both nationally and internationally in museums and galleries including the Walker Art Center, the Smithsonian Institute, the Philips Collection, P.S.1 Museum, the Stadkunst in Koln, the Museum of Modern Art in Japan, and the Getty Museum. Her writings have appeared in *Art Journal, Teme Celeste, M/E/A/N/I/N/G, Leonardo* and she has hosted and participated in numerous panel discussions such as *Monkey Business: Art and Science at the Millennium,* and *Sugar Daddy: The Genetics of Oedipus.*

Zoosemiotics (Primates),
1993

The year I was born, Barnett Newman painted a work called Genetic Moment in his search for a new beginning for painting. That fact was never lost on me. It is now a question of whether art is leading reality around or reality is leading art around, which seems to matter very little at this point, since time has collapsed so completely on itself.

When I began thinking about making these DNA paintings in 1987, it was apparent to me that we were living in a very, very different world than we were, say, three or five years before. I decided that I would make paintings that would confront the idea that we are about fifteen minutes into the future. Since I've been making these gene paintings, I don't know how many hundred thousands of advances and patents have been applied for in various disciplines. Until now we have been shaped by the invisible hand of Darwinian evolution, a process that learns from the past but is blind to the future. In contrast biotechnology threatens to take

DENNIS ASHBAUGH

great strides in envisaging the future. As it does, it becomes increasingly complex and further from the truth.

I'm interested in a variety of the disciplines that have altered or are altering life as we know it. It's clear biotechnology has reshuffled our concept of time by opening frightening new doors. It's altered what we eat. It's altered the face and future of the planet. It's altered weather. It's altered warfare and our basic concepts of politics and courtships, so all is fair. Dolly has a mother. It's pretty hard not to be affected by these facts.

36

A Guggenheim Fellow, Dennis Ashbaugh has shown his work widely since the 1970s including solo shows at P.S. 1, New York, La Jolla Museum of Contemporary Art, and Knoedler Gallery in London. His work is a part of the permanent collections of The Metropolitan Museum of Art in New York and the Hirshhorn Museum and Sculpture Garden in Washington DC, among other institutions. His work has recently been shown at the Ralls Collection, Washington, DC, the Betsy Senior Gallery, New York, and Galleri Antoinina Zaru in Capri, Italy.

Bio-Gel
(AKA The Jolly Green Giant),
1990–1991

Since the beginning of our collaboration in 1990, we have been interested in creating visual metaphors for the increasing role that new technologies play in our lives and how they affect us politically, socially, and psychologically. The recent advances in biotechnology and genetic engineering propose many questions about the boundaries between the natural and the artificial, as well as the role that aesthetics may play in "designed" forms of life that may emerge in a world of traditional notions of evolution. These possibilities can do nothing but trigger the imagination.

AZIZ + CUCHER

Anthony Aziz and Sammy Cucher have been collaborating on and exhibiting digital photography projects and sculpture since 1991. Their recent photo-based work reflects early experiences working in film, video, and experimental theatre. Aziz + Cucher have shown their work widely, most recently in a major solo exhibition at the Museo Nacional De Arte, Reina Sofia, in Madrid, Spain (1999) and in the Biennale de Lyon in Lyons, France (2000).

Interior #5, 1999

This piece attempts to selectively breed aquatic frogs originating from the Congo region of Africa. Hymenochirus curtipes was a once widely distributed species that over the past forty years may have been depleted from its native habitat perhaps become obsolete. (It has not been proven that H. curtipes is extinct from the Congo.) By controlled pairing of related species and/or subspecies, I hope to generate an H. curtipes model by literally breeding backwards, in an attempt to recapture surface traits through various generations. Recent literature suggests that biodiversity in the Congo is threatened by slash-and-burn clearing of forests and by increased economic demand for logging. Political chaos and civil turmoil in the newly established Democratic Republic of Congo, formerly Zaire, over the past decade have severely retarded biological studies. Amphibian populations are declining at an

BRANDON BALLENGÉE

unprecedented rate worldwide. The data available on the remaining species in the Congo is inconclusive.

Technical and theoretical support was provided by the following individuals and institutions: Dr. George Rabb, director, and staff, The Chicago Zoological Park, USA; Mr. Lawrence Wallace, Herpetological Department, Carolina Biological Supply, USA; Dr. Randon Feinsod, Exotics Department, The North Shore Animal Clinic, USA; Mr. David Cecere, The African Dwarf Frog Educational Website; The Department of Zoology and Marine Biology, University of Dar es Salaam, Tanzania; The Herpetological Department, The Bronx Zoo, USA; Dr. Stanley Sessions and staff, Biology Department, Hartwick College, USA; Mr. Peter Warny, The New York State Museum, USA; The Herpetological Department, The American Museum of Natural History, USA; The Declining Amphibian Population Task Force, Department of Biology, The Open University, UK

Ballengée has been studying amphibian declines and deformities for the past four years and has participated in and instigated numerous amphibian surveys throughout North America. He also serves as a field observer for the North American Reporting Center for Amphibians Malformations (NARCAM). In recent years, Ballengée has shown at diverse institutions such as the Queens Museum, New York, 2001; The DUMBO Arts Center, Brooklyn, 2001; the Hartwick College Science Center, Oneonta, New York, 2001; and The Central Academy of Fine Arts in Beijing, The Peoples Republic of China, 2001. Ballengée received the Emerging Artists Grant from the Wendel Foundation in Columbus, Ohio in 1992 and recently published "Deformative Amphibians: An Overview" published by the New York Herpetological Society's Journal, 2001. Ballengée will be co-teaching (with developmental biologist Dr. Stanley Session) an ecology art and neotropical evolution course at the Monte Verde Scientific Field Station in Costa Rica.

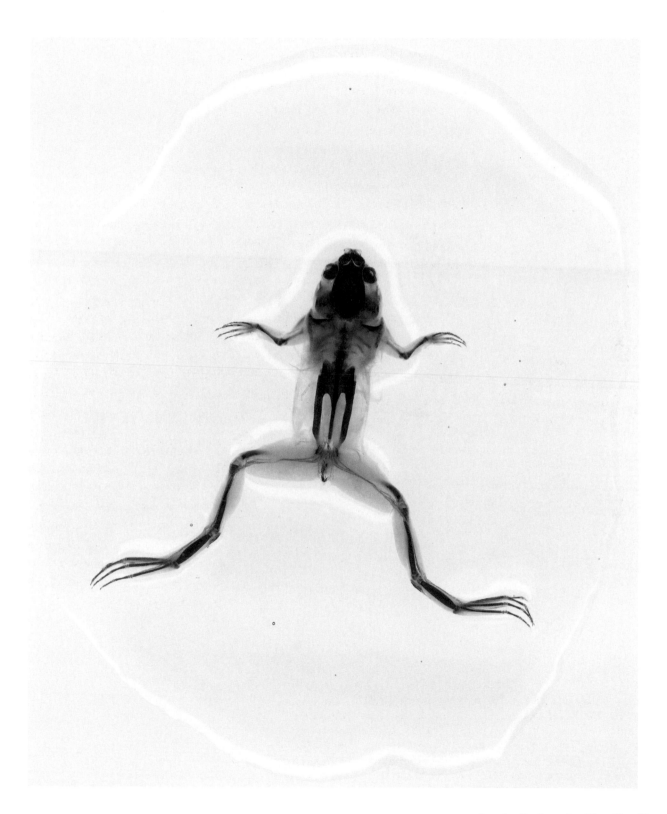

**Species Reclamation Via a Non-Linear
Genetic Timeline; An Attempted
Hymenochirus Curtipes Model Induced
by Controlled Breeding**, 2000 (detail)

I was introduced to the practical implications of the Human Genome Project when I was pregnant and was offered a routine test that could detect the probability of genetic abnormality in the fetus. This resulted in my participating in residency programs at several institutions, each of which dealt with a different aspect of genetics: The Medical Research Council's Social & Public Health Sciences Unit, Glasgow; the Institute of Medical Genetics, Yorkhill Hospital, Glasgow; and the Wellcome Trust Building in Dundee, Scotland. The following text is an extract from an essay that accompanied the project, written by Dr. Lisa Schwarz, a lecturer in the Philosophy of Medicine at Glasgow University.

Detection of genes that cause or carry particular conditions implies labeling the gene as desirable or undesirable, good or bad. Undesirable conditions can now be located by genetic testing. Enormous screening programs and routine prenatal testing for Down's syndrome and spina bifida are set up to detect the probabilities of a community or individual perpetuating the undesirable gene. The condition is thereby red-flagged but with what intention? In the case of conditions that are not yet curable, the only other option is to eliminate them before they affect the community. This means either eliminating the gene or the gene carrier. Ultimately it has become a reason for termination of pregnancy, and more recently the option to prevent coupling between gene carriers where a condition requires two carriers to activate it. How far down the line we will go, as mapping of the genome progresses, is as yet undetermined.

42

CHRISTINE BORLAND

Christine Borland is a Scottish artist who was nominated for the prestigious Turner Prize bestowed by The Tate Gallery in London in 1997 and awarded a scholarship at Kunstwerke in Berlin in 1996. She has been included in the 'Aperto,' the Venice Biennale, and has shown at the ICA, London; the De Appel Foundation, Holland; The Irish Museum of Modern Art, Dublin, and the Munster Sculpture Project, Germany, 1997.

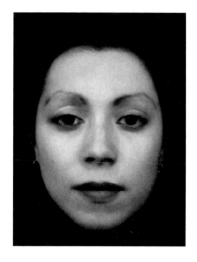

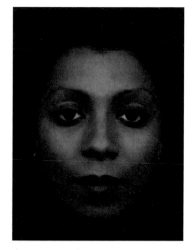

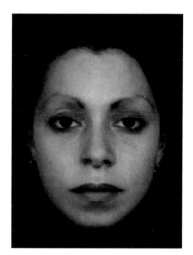

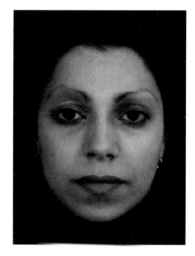

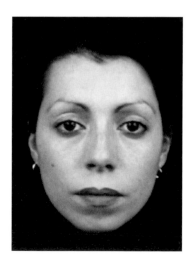

Selected images from
The Human Race Machine, 2000

HELEN CHADWICK

Helen Chadwick's work has appeared in numerous exhibitions including the National Portrait Gallery, the Barbican Art Gallery, the Serpentine Gallery, and the Institute of Contemporary Arts (all in London), as well as the Portfolio Gallery in Edinburgh. In 1987, Chadwick was nominated for the prestigious Turner Prize for her work of the previous year. Chadwick had just begun to exhibit widely at the time of her sudden death at age 42 in 1996.

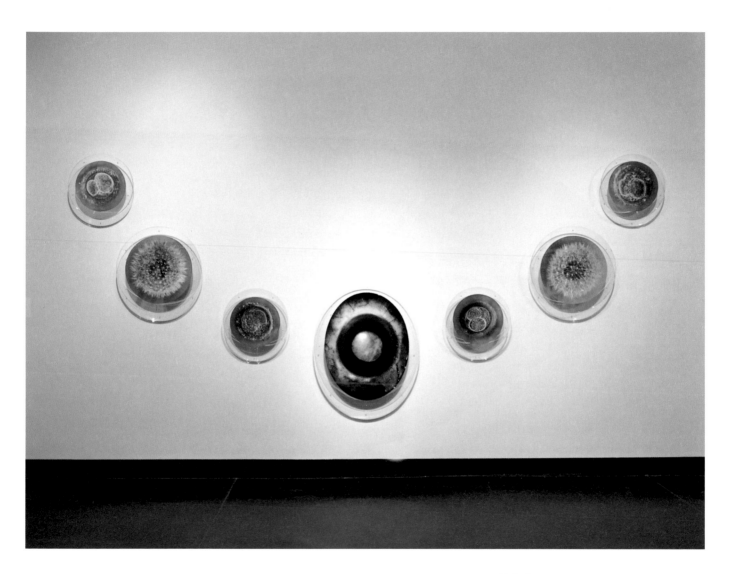

Nebula, 1996

In 1987, when my interests returned to genetics, researchers were using creative imaging strategies, including coding or advanced methods of photography, to display chemical units, which were otherwise invisible. The DNA sequence or the chromosome revealed itself through chemical reactions, such as pcr (polymerase chain reaction) or crystallography. While the codes employed by geneticists allude to real physical entities, their visualization originated in the imaginations of researchers. I found parallels to the art world of the late seventies and early eighties when the subject of the ordinary, the commonplace, was acknowledged, referenced as art through codes shared by the art community. Understanding semiology and its mother science, structural linguistics, enriched the experience of Conceptual Art. In both fields a fledgling belief system became consistently repeatable, predictable, and the basis for evermore precise experimentation.

KEVIN CLARKE

The chemistry interested me as a portrait photographer, as did the exploration of new ways of seeing people. Encountering the physicality of my sitters, conceived as a coded, readymade being, allows me to perceive them freely rather than define them socially, as does traditional photography with its many clichés, references, habits, and uses. A person's specific genetic code, a hereditary inscription, is a direct reference to that person's physicality. With these portraits I feel freed of ordinary representation and more open to interpretation. This portrait of James D. Watson, whose insights led to the discovery of the double helix model of DNA, is an exploration of structure and gesture.

Kevin Clarke earned his BFA in sculpture from Cooper Union in New York City in 1976 and has exhibited extensively throughout the US and Europe. Recent solo exhibitions were held at Galerie Michael Sturm, Stuttgart, Germany, 2000; Museum Wiesbaden, Germany, 1999, and the Grand Salon, New York, 1997. Clarke has participated in recent group shows such as *Blood: Power, Politics, and Pathology*, Schirn Kunsthalle and Museum for Applied Art, Frankfurt, 2001; *Under the Skin – Biological Transformations in Contemporary Art*, Stiftung Wilhelm Lehmbruck Museum, Duisburg, 2001, and *Genomic Art: Portrait of the 21st Century*, University of California at Santa Cruz, 2001. Clarke has published many books featuring his photography including: *The Invisible Body*, 1999, *Portraits, Kevin Clarke*, 1998, and *The Red Couch, A Portrait of America*, 1984.

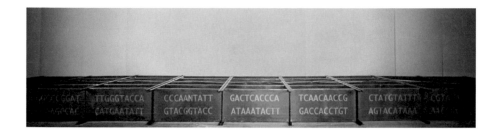

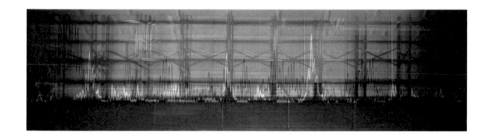

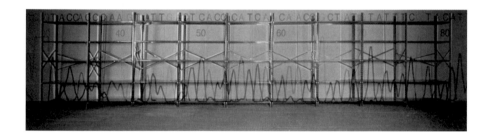

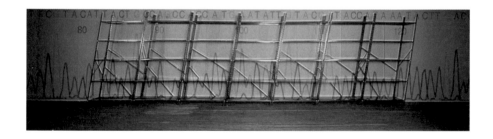

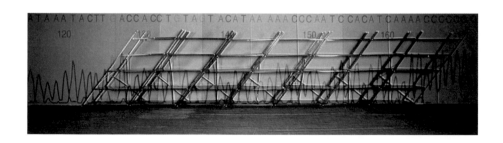

Portrait of James D. Watson,
1998–1999

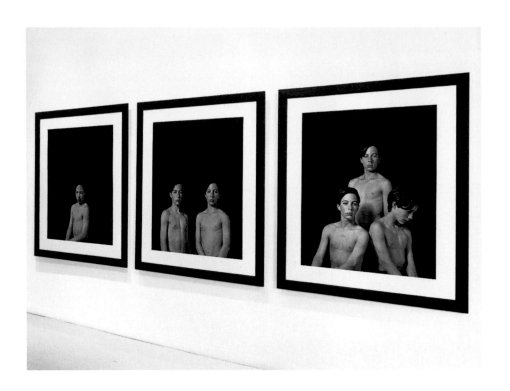

KEITH COTTINGHAM

In this series, I use the computer as a tool to draw upon traditional sculptures, models, photography, and drawings, and through the use of digital painting and montage, ideas materialize into finished photographic prints. The realism in my work serves as a revealing mirror of ourselves and our inventions, both beautiful and horrific.

The images themselves are portraits of a youth. By combining myself with others, these imaginary portraits expose the movement and development of the "Self." The soul is not seen as a solidified being, but is exposed as multiple personalities, each expressing a different view of the "Self."

I hope to simultaneously challenge what the viewer perceives as portraiture and question the alienation and fragmentation of image from matter, body from soul.

Keith Cottingham studied computer programming and art in San Francisco. His work has been featured in solo exhibitions at the Espace d' Art-Yvonamor Palix, in Paris, France, 2000, the Rudolf Mangisch Gallery, in Zurich, Switzerland, 2000, as well as Ronald Feldman Fine Arts, New York City, 1999. Cottingham's work has also been included in group shows such as *Identities: Contemporary Portraiture*, at the New Jersey Center for Visual Arts, Summit, NJ, 2001, and the *Somewhat Corrupt=Computer Art Show*, at the Plaza Gallery, Lowenstein Hall at Lincoln Center, Fordham University, New York, 2001.

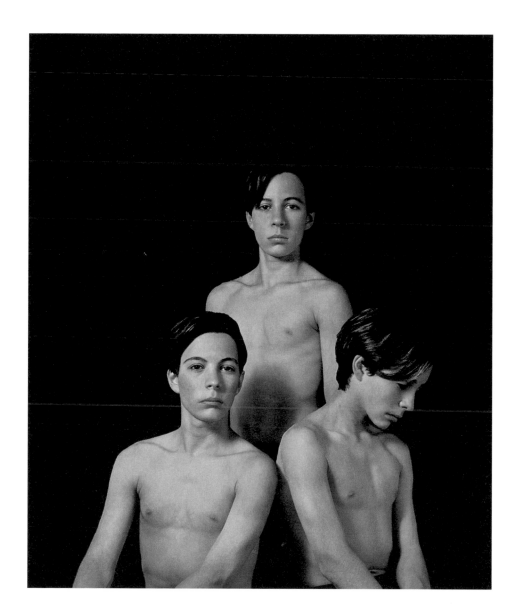

Fictitious Portrait Series, 1993

Transgenics is the practice of transplanting genes from one species to another, thus creating genetic hybrids that can develop characteristics of both species. Consider what is happening with genetics. For instance, the oncomouse is the first patented

BRYAN CROCKETT

transgenic lab mouse, engineered to have a human immune system for the purpose of oncology research. In this way, the practice of genetics can be understood as an analogy to the worlds of allegory and mythology. Like the Satyr or Minotaur, the oncomouse is the literalization of a cliché man/mouse. That is why I have chosen to reinterpret the ultimate figure of salvation, Christ, through the ultimate actor of contemporary science, the oncomouse. This sculpture is intended to be a monument to the test object of modern science, human kind's symbolic and literal stand-in personified. This human-scale, fleshy mouse, sculpted with the pathos of classical sculpture, stands six feet tall. He is nude (as is the oncomouse) and his flesh is a very convincing pale skin tone. Upon further inspection, however, one realizes the mouse/man is actually sculpted in flesh-colored marble. The lifelike sculpture and skin texture makes the sculpture oscillate between a living creature and a strong likeness, evoking the Pygmalion myth.

Bryan Crockett studied at The Cooper Union School of Art in New York and Yale University, where he earned his **MFA** from the School of Sculpture in 1994. Crockett's work has been exhibited in a number of group shows, including *Photasm*, Hunter College/Times Square Art Gallery, 2000; *Spectacular Optical*, Thread Waxing Space, New York, 1998, and the *1997 Biennial* of the Whitney Museum of American Art in New York. Crockett recently participated in several international exhibitions including: *Melodrama*, Artium, Centro-Museo Vasco de Arte Contemporaneo, Vitoria, Spain, 2001; *Self-Made Men*, DC Moore Gallery, New York City, 2001, and *Raum-Korper*, Kunsthalle, Basel, 2000.

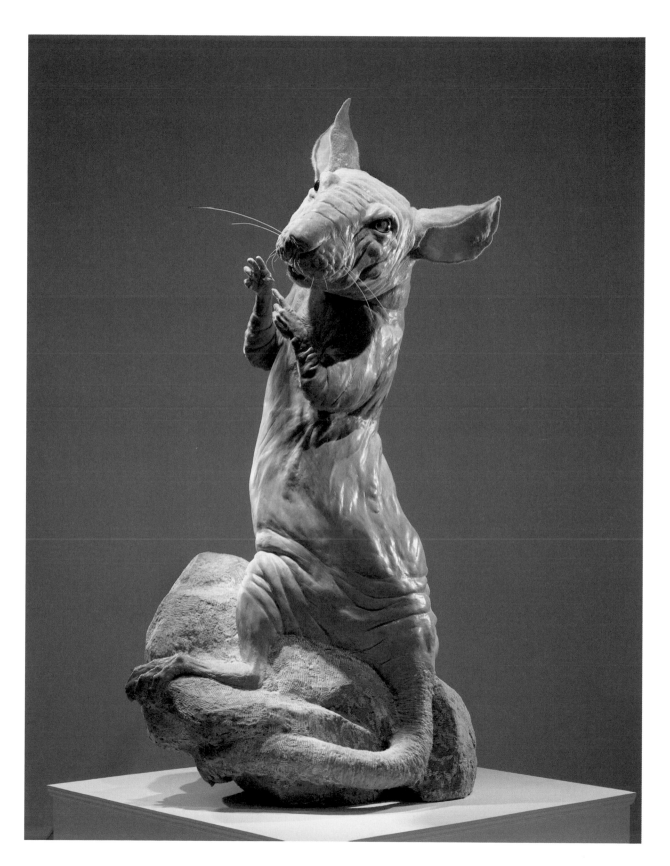

Ecco Homo Rattus, 2000

HANS DANUSER

INI MINI MEINI MOU

For more than ten years, Danuser has explored a wide range of society's most volatile issues including; nuclear energy; medicine; physics; and chemistry, and the production of gold. His work has been included in international exhibitions at institutions including, Stadtische Galerie im Lembachhaus, Munich; Zurich University, Zurich; The New Museum of Contemporary Art, New York; Kunsthaus Zurich, Zurich, Curt Marcus Gallery, New York; Kunstmuseum Bern, Bern; and Frankfurter Kunstverein/Schirn Kunsthalle, Frankfurt.

Frozen Embryo Series II,
1998–1999 (detail, one of five images)

My initial exposure and access to the genetic code grew out of discussions with my brother, who is a genetic researcher. At the time we were both reading about chaos theory. My work has often explored different historical scientific models; previously I had been working on the idea of the automaton. The genetic code seemed to be a radical shift from mechanics to communication, from how the body "works" (blood and guts) to how it "means" (blocks of letters). The idea of genetics as a universal language of life was something I found quite menacing. For *ACGT* (1998) I focused on the relationship between genetics and information theory, how the organizing and dissemination of genetic material can inform its use and, ultimately, how the body is conceived as information to be programmed and deciphered. What particularly caught my attention was the relationship between something that looks like a tangle of spaghetti through the microscope and the orderly string of code available on the Internet. I decided to work through this linear and seamless string of information in a very concrete, archaic, and messy way—with needle and thread—introducing a bit of Frankenstein, I suppose.

CHRISTINE DAVIS

Christine Davis has been showing her work internationally since the early 1990's. Her work has been featured in many international venues including **The Power Plant**, Toronto, 2000; Galeria Helga de Alvear, Madrid, 1999; Olga Korper Gallery, Toronto, 1995, and group exhibitions as well as collections in Basil, Switzerland, Berlin, Germany, and Madrid, Spain. Davis is the founding editor of the interdisciplinary journal, *PUBLIC*.

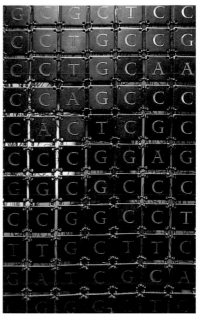

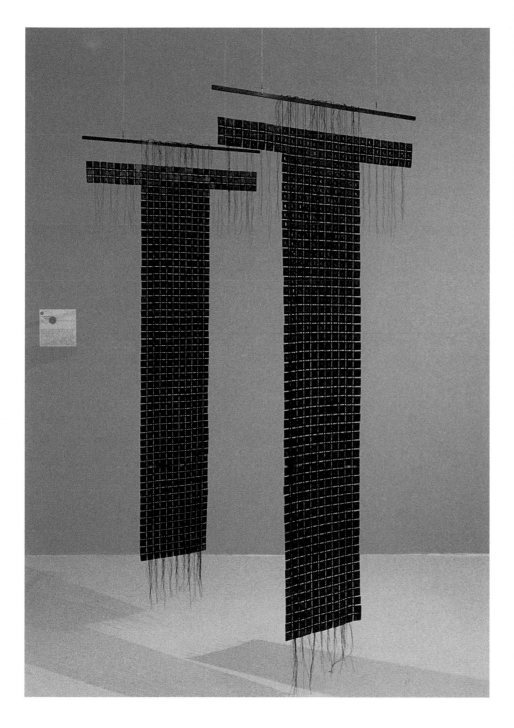

ACGT I and II, 1998–1999

detail above

MARK DION

1. The biotech industry claims that genetic engineering is merely a new technology developed to overcome some of the problems of traditional selective breeding techniques. In fact it greatly differs from traditional husbandry and agriculture by allowing novel organisms to be produced across species boundaries. A traditional farmer could never cross a fish with a strawberry, or glowworm with tobacco, both of which have already been released in agribusiness fields. 2. Exotic organisms introduced to new ecosystems cause massive amounts of ecological disruption, including species extinction. Genetically modified organisms could (and already have) easily escape growth sites, and if their built-in resistance to herbicides and pathogens is transferred to a weed, there is potential for "superweeds." 3. Who wants GMOs? Many of the most ecologically destructive and untrustworthy multinational corporations. It is they who will profit, and despite the utopian rhetoric, they have often proved to not work in the public interest. They cannot be trusted. 4. Overwhelmingly, the public would rather not be exposed to GMOs in food. The biotech industry arrogantly disregards consumer concern. The public has little or no say in the application of genetic engineering. 5. The public is not well informed about issues of genetics and the biotech industry is spending millions on propaganda disguised as educational material. 6. The introduction of GMOs in food is not driven by a desire to make food taste better, become more nutritious, or even stay fresh longer. Rather, there is little benefit beyond increasing the financial gain reaped by giant agribusiness corporations and biotech companies. 7. While promising to reduce chemical use on farms, GMOs in fact lead to even greater chemical dependence. Indeed, some crops are even precisely modified to withstand higher doses of herbicides. 8. Field tests have proven that GMOs harm beneficial insects and fungi, damage soils, contaminate neighboring fields, and hybridize with non-modified crops. 9. Genetically engineered organisms increase farmers' dependence on large multinational agro-corporations. Modified crops do not produce fertile seeds. Farms cannot save seeds and must purchase new ones from biotech companies each year. Since farmers in the developing world rely on saved seeds many development policy groups and environmental groups believe that rather than solving the hunger crisis, GMOs could actually lead to a worsening of the problem 10. History has shown that most new industries have unforeseen negative long-term consequences. Thus caution should be used and long-term testing should be applied by the biotech industry. In the rush to cash in on novel techniques, and under the pressure of the chemical and agricultural industries, neither the FDA, the USDA, nor the EPA have yet established testing protocols, thereby leaving the testing to the industries themselves.

Mark Dion received his BFA from the School of the Visual Arts in New York and attended the Whitney Independent Study program. Dion has shown widely in recent years, including the project-based installations, *Parasite*, The Drawing Center, New York, 1998; *Grotto of the Sleeping Bear*, Westfalisches Landesmuseum for the Arts Tour, 1997, Munster, Germany; *Culture in Action*, Chicago, 1995, and recent projects at American Fine Arts, New York; The Tate Art Gallery, London; and the Fuller Museum of Art, Brockton Massachusetts.

Daily Planet, 1991

I began as a painter. The transition to plant breeding was through painting on Japanese papers, which absorb water and pigments in unpredictable ways. I became fascinated by how ink spots grow on unprepared papers. Watching them grow, and helping them along, I no longer felt like a lone artist, but connected to creative energies that already reside in materials and in the world. From ink spots to plant breeding was only a small step. Plants, like ink spots, generate themselves. My job is to facilitate.

GEORGE GESSERT

Gessert began life on a farm in Wisconsin, before training as an artist and working in New York as a freelance illustrator. In 1975, Gessert returned to school and studied horticulture and has continued since then to work as an artist and graphic artist. He was an artist-in-residence at the Exploratorium in San Francisco in 1995 and a recipient of the Coler-Maxwell Medal for Excellence from *Leonardo*/MIT Press in 1993. He has published numerous articles over the past ten years. Recent writings include "A Brief History of Art Involving DNA," *Art Papers*, 1996, and "Art and Biology," *Leonardo*, 1997.

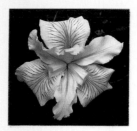

Hybrid 545 (Big Money x Hybrid 73)
1991. First bloom 1995. Diameter 3.25"
Stem 14"

At first This iris seemed moderately
vigorous, but by 1996 it had become
very weak. Composted.

Parent: hybrids 932-938

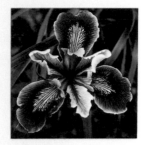

Eduardo Kac. Hybrid 485 (Hybrid 22 x
Olaf Stapledon) 1990. First bloom 1994.

Strong overall pattern. Vigorous.

Registered as 'Eduardo Kac' with the
American Iris Society.

Parent: hybrids 1021-1036

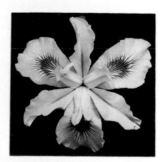

Hybrid 611 (Canyon Snow x Hybrid 252)
1992. First bloom 1994. Diameter 4.5"
Stem 15"

Vigorous, but a somewhat shy bloomer.

Parent: hybrids 1030-1051, 1082-1090

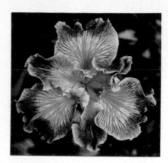

Hybrid 1015 (Pac 4 x Hybrid 678)
1995. First bloom 1998. Diameter 3"
Stem 15"

If I were breeding for ugliness, This would be
a triumph. It has all The worst clichés of
iris breeding: extravagant ruffles, overlapping
flower parts, confused overall form, and
garish color.

Regarding the use of my DNA:

I've heard an art dealer say that getting money from collectors is like asking them to rip veins out of their arms.

I've felt at times like I've *given* blood, making my art, and participating in the art world.

But I've never been asked for blood, or DNA, for an art show, and it is a very odd sensation.

I find the request intelligent, somewhat invasive, and not so innocent. My DNA is the recipe of me (not yet patented!) and I'm wondering what you would do with it. The question itself evokes a very queasy feeling (what *could* they do with it?) a very paranoid feeling (what *could* they find out or reveal about me)

REBECCA HOWLAND

a guilty feeling
(what have I done?)
and a vulnerable feeling
(anyone walking past me on the street could swipe some)
I'm thinking Matrix here!

Genetic mapping and reproductive technology are compelling to me. Genetics hits in the potent intersections of personal and environmental disaster and healing. Creation, and destruction, at its root,—how could this *not* interest an artist? We are the antennae. Here, we are doing our job. Big business, big money, big trouble = totally fascinating, and not necessarily a bad thing, even as I hear the sound of my own knee jerking.

An artist and activist, Rebecca Howland co-founded **ABC No Rio**, an artist and community center in the Bronx, and is a founding member of the artist group Collaborative Projects (CoLab). She received her **BFA** in sculpture from Syracuse University in 1973, attended the Whitney Independent Study Program in 1974 and received her **MFA** in painting from Bard College in 1998. She has shown widely since her first major exhibition in New York, the *Real Estate Show*, which was mounted by CoLab in Times Square in 1980.

Other exhibitions include *Transmission Towers* at P.S.1, Long Island City, 1986; *Flowers and Towers* at the Willoughby Sharp Gallery, New York, 1988; *Cultural Economies* at The Drawing Center in New York, 1996; and *Urban Mythologies* at the Bronx Museum of Art, 1999.

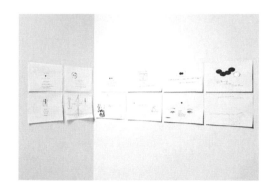

I ask Gelek Rinpoche
 Tibetan Buddhist:

if they make a clone of me
 does my spirit come too?

He says: no, same apartment,
 different tenant

Drawings from **The World
in a Drop of Blood**, 1999–2000

Onetree is actually one hundred tree(s), clones of a single tree micropropagated in culture. These clones were originally exhibited together as plantlets at Yerba Buena Center for the Arts, San Francisco, in 1999. This was the only time they were seen together. In the spring of 2001, the clones will be planted in public sites throughout the San Francisco Bay Area, including Golden Gate Park, 220 private properties, San Francisco school district sites, Bay Area Rapid Transit stations, Yerba Buena Performing Arts Center, and Union Square. A selection of international sites are also being negotiated. Friends of the Urban Forest are coordinating the planting. Because the trees are biologically identical, they will render the social and environmental differences to which they are exposed in subsequent years. The trees' slow and consistent growth will record the unique experiences and contingencies of each public site. The trees will become a networked instrument that maps the microclimates of the Bay Area, connected through their biological materiality. People can view the trees and compare them, a long, quiet, and persisting testament to the Bay Area's diverse environment.

Cloning has made it possible to Xerox copy organic life and fundamentally confound the traditional understanding of individualism and authenticity. In the public sphere, genetics is often reduced to "finding the gene for (fill in the blank)," misrepresenting the complex interactions of the organism with environmental influences. The swelling cultural debate that contrasts genetic determinism and environmental influence has consequences for understanding our own agency in the world, be it predetermined by genetic inevitability or constructed by our actions and environment. The Onetree project is a forum for public involvement in this debate, a shared experience with actual material consequences.

NATALIE JEREMIJENKO

Natalie Jeremijenko, a 1999 Rockefeller fellow, is an inventor and engineer whose work focuses on the design and analysis of tangible digital media. Recently, named one of the top one hundred young innovators by the MIT Technology Review, Jeremijenko recently exhibited at the Museum of Modern Art, the Media Lab at the Massachusetts Institute of Technology (MIT), the 1997 Whitney Biennial, Documenta '97, Ars Electronica, 1996, and her installation, *Tree Logic*, at MASSMoCA in North Adams, Massachusetts, 1999. Prior to her appointment at the Media Research Lab/Center for Advanced Technology in the Computer Science Department of New York University, Jeremijenko was director of the Engineering Design Studio at Yale University.

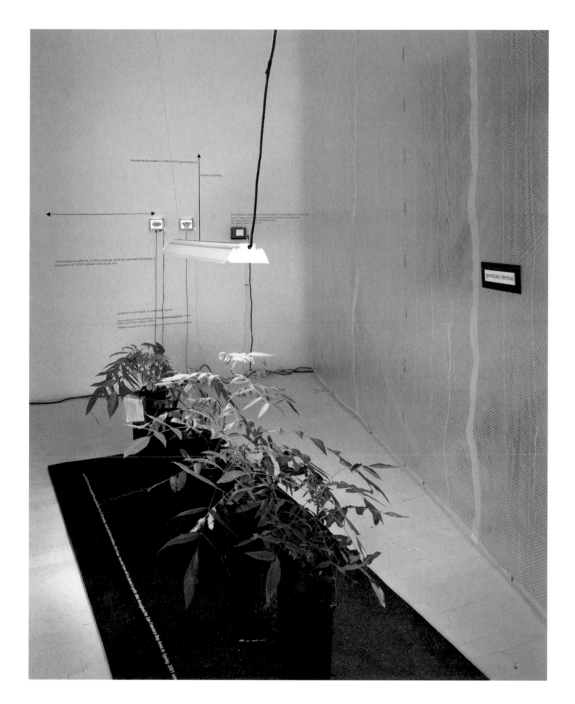

Onetree, 2000

"This sculpture may seem familiar. It shadows a particular sculpture by Jean Arp. But my sculpture takes hostage Arp's intuitive search for a higher modern form, a utopic or perfect order and perverts it into something distressed and dying, a promise unkept to the culture at large. This bronze literally depicts the genetic structure of cancer. It aspires to be beautiful in a way that is aligned with the idea of beauty as an overwhelming and powerful tool. Dave Hickey has written:

The task of these figures of beauty was to enfranchise the audience and acknowledge its power—to designate a territory of shared values between the image and its beholder and, then, in this territory, to argue the argument by valorizing the picture's problematic content.

RONALD JONES

Hickey's words do double service here, calling out the way in which the beauty of this sculpture foregrounds disease as a political subject, a subject that reminds us all of what it means to be dispossessed in our culture."
From a lecture given at the Yale School of Art, 1989

Ronald Jones is a widely exhibited artist, respected art critic, and Chair of the Visual Arts Division at Columbia University. Recent exhibition venues include *Comfort Zone*, Public Art Fund & Painewebber Gallery, New York, 1999, *Critical Interventions:*

Evil, John Hansard Gallery, University of Southhampton, Highfield, England, 1998, and "Defining Structures," Nations Bank Plaza, Charlotte, North Carolina, 1998. Jones has

also conceived several garden projects including: the design and execution of Pritzker Park in Chicago, the Rethymnon Centre of Contemporary Art in Crete, and the Botanical Gardens in Curitiba, Brazil. Jones's recently published criticism include "Continued Investigation of the relevance of Abstraction," *Frieze*, 1999,

"The Power of Beauty," *Art & Design*, 1998, and "The Best of 1998," *Artforum*, 1998.

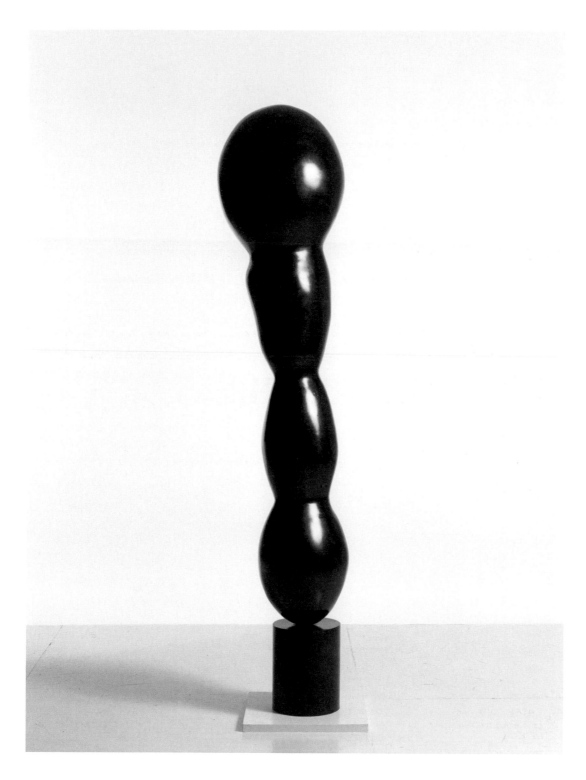

Untitled (DNA Fragment from Human
Chromosome 13 carrying Mutant Rb
Genes also known as Malignant
Oncogenes that trigger rapid Cancer
Tumorigenesis), 1989

EDUARDO KAC

I investigate the philosophical and political dimensions of communications processes. Equally concerned with the aesthetic and the social aspects of verbal and nonverbal interactions, I examine linguistic systems, dialogic exchanges, and interspecies communication. In 1998, to further expand my investigation of communications processes, I proposed Transgenic Art, a new art form based on the use of genetic engineering techniques to transfer synthetic genes to an organism or to transfer natural genetic material from one species into another in order to create unique living beings. The nature of this new art is defined not only by the birth and growth of a new plant or animal, but above all by the nature of the relationship between artist, public, and transgenic organism—which must be respected, loved, and nurtured like any other organism.

Eduardo Kac is a Ph.D. research fellow at the Center for Advanced Inquiry in Interactive Arts (CaiiA) at the University of Wales, Newport, United Kingdom, and an Associate Professor of Art and Technology at the School of the Art Institute of Chicago. Kac's work has been exhibited internationally at venues such as Exit Art and NY Media Arts Center, New York; OK Contemporary Art Center, Linz, Austria; Inter-Communication Center (ICC), Tokyo; Chicago Art Fair and Julia Friedman Gallery, Chicago; and Museum of Modern Art, Rio de Janeiro. Kac's work has been showcased in biennials such as 1st Yokohama Triennial, Japan, 48th International Venice Biennale, Italy, 1st Mercosul Biennial, Brazil, and 4th Saint Petersburg Biennial, Russia. His work is part of the permanent collection of the Museum of Modern Art in New York, and the Museum of Modern Art in Rio de Janeiro, among others.

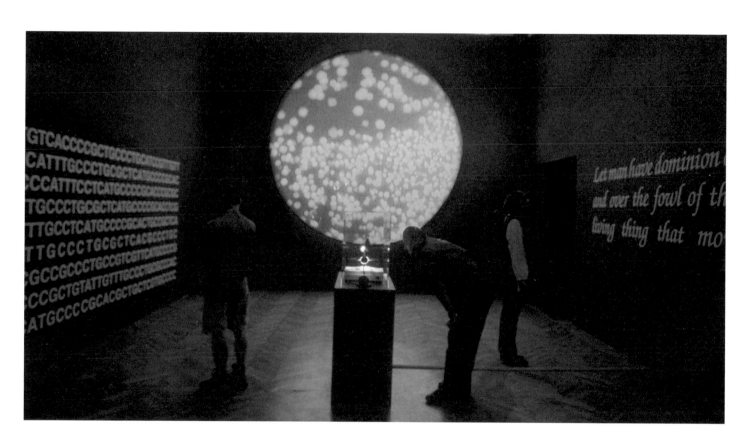

Genesis, 1999

DAVID KREMERS

in 1992 i began growing paintings from bacteria on plates of clear acrylic, using bacteria that was genetically engineered to produce enzymes of various colors. it's like painting on a piece of ice with melted snow. after eighteen hours in an incubation chamber the image grows into the shapes and colors the bacteria and i have collaborated on. the plates are then dried and sealed in a synthetic resin. future conservators, a millennium away, may remove the resin, feed the bacteria, and continue the life of the work. the figurative subjects were chosen from early embryonic structures common to all mammals. evolution as a step of physiology-based intelligence.

davidkremers' first architectural work was commissioned in 1975 and he added ornamental horticulture to his menu in 1982. davidkremers's art is represented in major collections, including those of the San Francisco Museum of Modern Art, Broad Art Foundation in Los Angeles; the Collection of Count Giuseppe Panza di Biumo, and The Peter and Eileen Norton Collection. He currently serves as the Caltech Distinguished Conceptual Artist in Biology in Pasadena, California. davidkremers is author of several essays on art and life, among them "The Delbruck Paradox," written for Ars Electronica and "Art Minus Contemplation" for the Mondriaan Foundation. He has a digital retrospective hosted by the Center for the Digital Arts at UCLA (www.cda.ucla.edu/events/lacma).

Trophoblast, 1992

There is an interesting correspondence between acquired memory and memory that is genetically encoded within the cells of our bodies. Both types of memory are pivotal to identity. Yet a distinction between the fixed and the mutable blurs to the unaided/uninformed eye while being fully sensed and known in other measurable ways.

We have come to understand ourselves differently in this time when scientific research is rapidly probing the once invisible space of the body unraveling ingredients and exposing chance operations that determine identity and define unique inherited differences. The compression of this vast archive of information into simple codes is fascinating in that it records abstract patterns that are layered with personal information. Siting my work in a hybrid arena of painting and science, the exchangeable liquid cultures of the laboratory and studio provide a context

JANE LACKEY

through which I can sample and mix intuitively. The subjective fields of my paintings trace those things that slip through the filter of order provoking perceptual, psychological, and physical interplay.

An ongoing parallel interest in the history of cloth has informed my study of pattern and code, illuminating the ways in which the science of DNA magnifies the significance of pattern. The genetic "fingerprint" of an individual is recognized through matching sequences that repeat in our DNA. With concise precision, complex social and personal questions of identity are reduced simply to patterns of dots, plaids, stripes, stains, smears, and strings of letters. Just as with language, the slightest change alters meaning. Framed within this intersection between the disciplines of painting, science, language, and textiles, is an ambient space where questions about how abstraction retains memory and new forms come into being can be challenged and rearranged.

72

Jane Lackey is currently serving as an artist-in-residence at Cranbrook Academy of Art in Bloomfield Hills, Michigan. She has had many solo and group shows throughout the US over the past fifteen years including recently at *On Language:*

Text and Beyond, Center Galleries, Detroit, Michigan, 2001, *Critical Eyes*, MoNA – The Museum of New Art, Pontiac, Michigan, 2000, and "Remnants of Memory," Asheville Art Museum in North Carolina, 2000. Lackey received an Illinois Arts Council Artists Fellowship in 1997 and a National

Endowment of the Arts Individual Artist Fellowship in 1988 and 1984. Her work is in numerous public and private collections.

smear (3), 2000

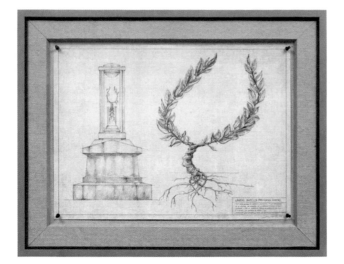

JULIAN LAVERDIERE

Laurus Nobilis is the true laurel of classical antiquity. The chosen plant of the Greek god Apollo, Laurel originated from the transubstantiation of Daphne, the woodland nymph whom metamorphosed into Laurel when fleeing Apollo's amorous advances. This sacred plant is recognized as the symbol of Apollonian knowledge, and was perceived as a symbol of immortality in ancient Greece and Rome, where it also became the emblem of nobility and victory. The Laureate was a crown woven of springs of Laurel and was worn on the brow of each triumphant Roman general as he rode his chariot around the Circus in celebration. Conversely, withering or diseased Laurel was believed to be a pertent of disaster.

It is thought the king is dead; we will not stay, the Laurel trees in our country are all withered, and meteors fright the fixed stars of heaven.

— Richard III, William Shakespeare

The Laurel is also symbolic of poetry and wisdom and is still honored today in the titles Poet Laureate and Nobel Laureate. As with plant genealogies, the code of our own genome is being deciphered and the wondrous and frightening implications of genetic determinism are gathering momentum. The gift of genius and strength may soon be obtained by intentionally reconfiguring our genetic building blocks. Enlightenment may be achieved through the administration of regenerative medicine. The illuminati will be cultivated in the test tube, not the temple. Scholastic study, trial, error, and happenstance will be rendered obsolete as a means of determining the intellect. Laureation will occur as commonly as germination. GENIUS WILL BE DESIGNED TO ORDER AND GROWN ON TREES.

Julian LaVerdiere runs a production company for commercials and fashion magazine layouts in Manhattan and graduated from the Graduate School of Art at Yale University in 1995 and The Cooper Union in 1993. His work was featured earlier this year in The Museum of Modern Art / PS1's influential survey of work by emerging artists, "Greater New York." His work was included in *DESIGN matters*, at the Museum of Contemporary Art (MOCA) in North Miami, Florida in 2000; *Open 2000*, in Lido Italy, and *Experimental Design 99* at the Portuguese Biennial. His recent proposal for a monument to the World Trade Center with Paul Myoda was featured on the cover of the September 23rd 2001 *New York Times Magazine*.

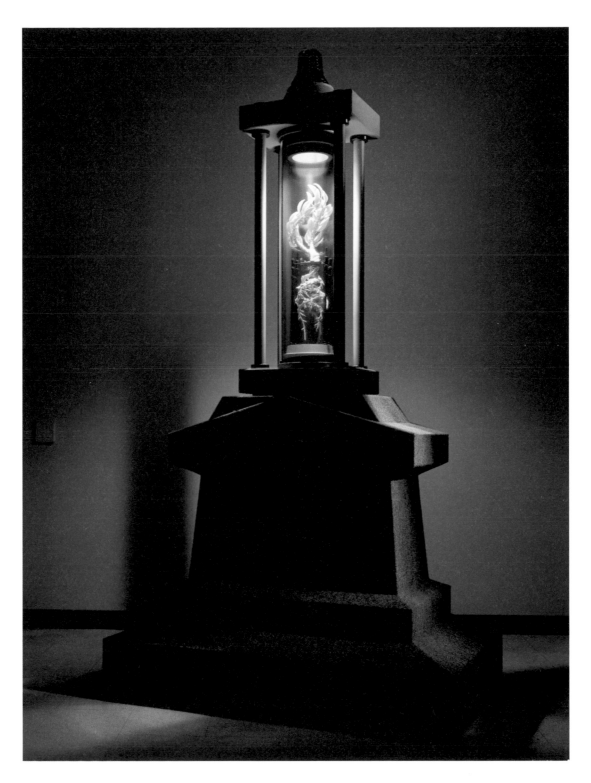

Transgenic Laureate, 2000
and on opposite page
Transgenic Laureate Plan, 2000

A gender-selected cryogenic sperm bank, *Banks in Pink and Blue* consists of a number of distinct components and agreements integral to the creation of a sculpture intended to preserve the viability of donated or "lender" sperm samples in cryogenic suspension for an undetermined period of time. While each sample is understood to be the property of the lender, the work functions as a corporate entity and generates appropriate contractual agreements with individual donors regarding preservation, ownership, and use of samples, including agreements between donors and the institutions that preserve and publicly display these samples. The project involves the contributions of twenty-five to one hundred sperm lenders selected by the artist as well as the participation of medical ethicists, geneticists, private biotech companies, lawyers, and legal consultants. *Banks in Pink and Blue* brings together disparate concerns of aesthetics, genetics, law, and ethics, addressing such issues as the possible transfer of sample

specimens in the medium of liquid nitrogen. One of the outer aluminum shells of these repositories is colored pink, and the other a light blue. Since the banks must be periodically replenished with liquid nitrogen, the installation also contains a large stainless steel tank, which is used to maintain the frozen semen specimens at -321°. The vessels and the samples they contain are displayed as sculpture in the gallery setting.

Each lender is provided with a kit containing cryogenic transport media and instructions for private

76 IÑIGO MANGLANO-OVALLE

ownership from the lender to the corporation or to other individuals. This installation includes a pair of self-contained cryobanking systems, the portable repositories known as Dewar flasks used by genetic laboratories, and commercial sperm banks for the preservation and long-term storage of

semen collection. The sample is then shipped to the artist by overnight air service for centrifugal separation for gender selection of spermatozoa carrying the Y- or X-sex determinant chromosome. Each sample is then stored in the appropriate pink or blue cryobank. The project is investigating the possibility that the artwork may have a predetermined lifespan of twenty years, which would allow for its exhibition at other venues at future dates.

Iñigo Manglano-Ovalle earned his MFA from the School of the Art Institute of Chicago in 1989 and spent his childhood in Spain and Colombia. He has participated in many group shows including: *Best of the Season: Selected Work from the 1998–99 Manhattan*

Exhibition Season, The Aldrich Museum of Contemporary Art, Ridgefield, Connecticut, 1999; the *XXIV Bienal de Sao Paulo*, Brazil, 1998; and recently showed solo work at the Institute of Visual Arts, University of Wisconsin –

Milwaukee, 1999; the Max Protetch Gallery, New York, 1999; and the Museum of Contemporary Art, Chicago, 1997. Manglano-Ovalle has been commissioned by the Henry Art Gallery in Seattle, Washington, and was recently featured in the *2000 Biennial* at the Whitney Museum of American Art.

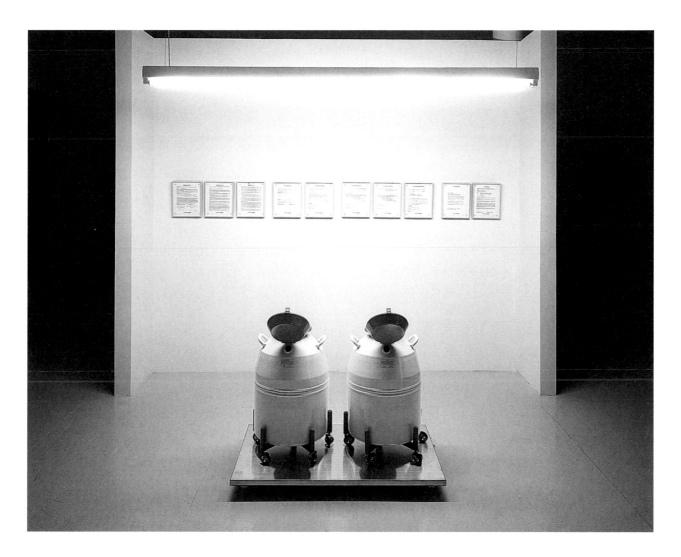

Banks in Pink and Blue, 1999

The end of the twentieth century witnessed a heightened interest in biotechnology in the general populace due to the many discoveries and breakthroughs in the life sciences. Nothing is more important to the earth's inhabitants and our ecosystem today than the life sciences. Artists were amongst those so piqued, resulting in an increase in artistic production, particularly in the year 1998. Recognizing this unique moment in our cultural history and the ripeness of the art world, we at Gene Genies Worldwide© launched a series of projects to engage both artists and scientists, like ourselves, in a dialogue on the culture of genetics. An example of such a project is *The Creative Gene Harvest Archive*. *The Creative Gene Harvest Archive* is a display of hair samples from people who are representative of creative individuals. The archive, with samples harvested by Gene Genies Worldwide©, is the cutting-edge of art and genetic engineering. This never-before-seen collection, existing nowhere else in the world, was generously lent for this exhibition by Gene Genies Worldwide©.

KARL MIHAIL AND TRAN T. KIM-TRANG

78

Mihail and Tran established Gene Genies Worldwide©™ in 1998 with the launching of a (conceptual) genetic boutique in Pasadena, California, which they marketed as a place of infinite possibilities for remaking oneself.

Karl Mihail received his MA from California State University in Fullerton, California in 1982. Recently, Mihail has shown at Side Street Projects in Los Angeles, California, 1999, Ars Electronica, 1999, and the Oregon College of Art and Craft in 1999.

Tran T. Kim-Trang received her MFA from California Institute of the Arts (CalArts) in 1993 and has screened her works in video widely throughout the US and Europe including such venues as The Whitney Museum of American Art, New York; The Museum of Modern Art, New York; and the ZKM Center for Art and Media in Germany. She is the Assistant Professor of Media Studies at Scripps College. Tran is a 2001 Rockefeller Film/Video/Multimedia Fellow and serves on the College Art Association Board of Directors.

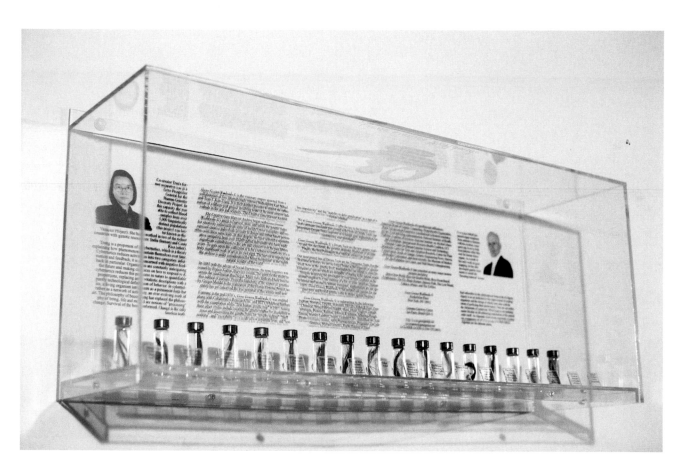

The Creative Gene Harvest Archive, 1999

LARRY MILLER

In the DNA molecule, I saw an analogy to the alchemist's quest for the philosopher's stone and the elixir of life. When the patenting of animals was approved by the Supreme Court in the 1980s, I concluded that if DNA is com-modified in the Genetic Revolution, then humans need legal rights to their personal genomes. I initiated a public action by pro-claiming "copyright" of my DNA in 1989, and then distributed my Genetic Code Copyright forms inter-nationally in eight languages. Subsequent "Genesthetics" works treating genetics as an art form continue my inter-ests in bridging concerns of art, science, and theology.

Known for his Fluxus-related work, conceptual artist Larry Miller has been exploring social and economic issues raised by genetic research in his performances, sculptures and installations for more than a decade.

Larry Miller is a veteran Fluxus performance artist and contemporary genetic rights art activist whose work and performances have appeared internationally for three decades. Miller has performed many times in venues such as: The Whitney Museum of American Art; The Newark Museum, New Jersey; Franklin Furnace, New York; the Alternative Museum, New York, and The Kitchen, New York. Among Miller's numerous recent solo exhibitions and performances include: *Genesthetics: Corpus Illuminatus*, Caterina Gualco Galeria, Genoa, Italy, 2000; *Flux Solo* (performance), Villa Solaria, ant'Andrea di Rovereto, Chiavari, Italy, 2000, and *DNAid*, public art project, Creative Time, New York, 2000. Miller received the National Endowment for the Arts Artist Fellowship (New Genres) in 1989, and the New York Foundation for the Arts Fellowship (Conceptual/ Performance) in 1986.

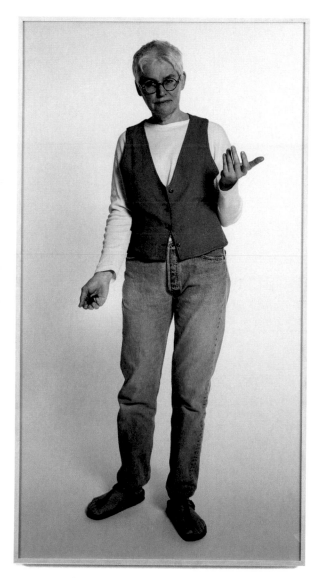

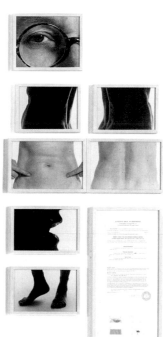

Genomic License No. 5
(Alison Knowles Properties), 1992–97

In 1992, I began investigating the genre of portraiture by using new medical imaging technologies. I inspected the painted portrait, which had been marginalized by photography, by examining the organic interior of the human body. In these portraits, the sitter's identity is no longer limited to outward appearance, but viewed through medical images, such as x-ray, MRI, sonogram, EKG, and CAT scans. Rather than being a depiction, these new portraits focused on identification using internal vistas and abstract symbols of medical nomenclature.

STEVE MILLER

In 1993, the art collector Isabel Goldsmith approached me to paint her portrait. Working on portraits at the electron microscope level was a logical extension of my previous investigations using new technologies in traditional art categories. I proposed doing a genetic portrait, and took a blood sample from Ms. Goldsmith to the John Innes Center in Norwich, England, for processing. The nuclei from her white blood cells were placed in a French bean culture, where her chromosomes went through mitosis for two weeks. The chromosomes were then photographed under an electron microscope, numbered and classified by size by the geneticist Pat Heslop-Harrison.

Steve Miller, a graduate of the Skowhegan School of Painting and Sculpture, has been producing work in digital formats since 1984 and has exhibited extensively throughout the United States, Europe, and Asia and is included in numerous public and private collections. Miller recently exhibited his *Neomort* show at Universal Concepts Unlimited in New York. His work has been widely shown over the past ten years at venues such as: the Public Art Fund/Times Square Electronic Bill Board, the CAPC Musee Bordeaux, France, and the Centre National d'Art Contemporain de Grenoble, France.

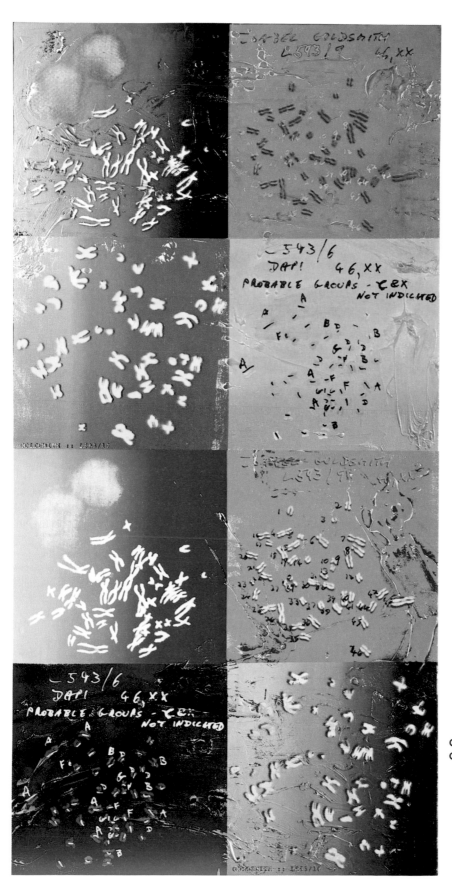

Genetic Portrait of Isabel
Goldsmith, 1993

HOW GENETICS BECAME MY SUBJECT

Jack and the Beanstalk ⟶ Burpee (childhood garden) ⟶ Biology Nerd
I am fascinated by Sci-Fi Eco Freak ⟶

Make painting of GMO [1988] ⟶ I get AIDS ⟶ Study human and viral genetics ⟶

rDNA Erythropoietin [Epogen]
I take: rDNA G-CSF [Neupogen] ⟶ the stuff works ⟶ Study genetic engineering ⟶
rDNA GM-CSF [Leukine]
rDNA HGH [Serostim]
rDNA Insulin

Invest in Amgen ⟶ Many paintings about AIDS, many representing genetic structures ⟶

Discover genetically modified organisms (GMOs) in my diet ⟶ I read: *Les particules elementaires* --Houellebecq ⟶

Begin file on genetic engineering ⟶ Dolly ⟶ Read critics of genetic engineering: Jeremy Rifkin
Dr Mae-Wan Ho
Vandana Shiva ⟶

Conceive solo show of paintings focused on genetics

FRANK MOORE

Frank Moore attended the Skowhegan School of Painting and Sculpture in 1973 and received his **BA** in painting from Yale University in 1975. His first one person show, the "Birds and the Bees" was held at the Clocktower in New York in 1983 and was followed by several solo exhibitions at Paula Allen Gallery and Sperone Westwater in New York. Moore's paintings have been included in many group exhibitions including The 1995 Biennial Exhibition at the Whitney Museum of American Art. He has collaborated with choreographers and filmmakers in performances at the Dance Theater Workshop, Jacobs Pillow Dance Festival, Lincoln Center, and Centre National de Danse Contemporaine d'Angers among others. Moore is also an accomplished critic and activist, and continues to work on many health and environmental issues.

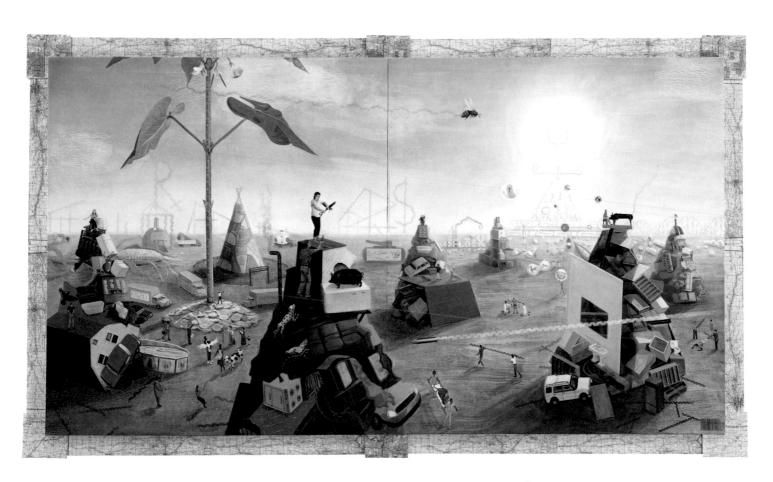

Oz, 2000

My artworks are information-rich depictions of how our culture perceives and interacts with plants and animals, and the role culture plays in influencing the direction of natural history. The Farm contextualizes the biotech industry's explosive advances in genetic engineering within the history of agriculture,

ALEXIS ROCKMAN

breeding, and artificial selection in general. The image, a wide-angle view of a cultivated soybean field, is constructed to be read from left to right. The image begins with the ancestral versions of internationally familiar animals—the cow, pig, and chicken—and moves across to an informed speculation about how they might look in the future. Also included are geometrically transformed vegetables and familiar images relating to the history of genetics. In The Farm I am interested in how the present and the future look of things are influenced by a broad range of pressures—human consumption, aesthetics, domestication, and medical applications among them. The flora and fauna of the farm are easily recognizable; they are, at the same time, in danger of losing their ancestral identities.

Alexis Rockman began showing his work in 1985 after attending the Rhode Island School of Design and the School of Visual Arts, New York. His work has been exhibited in solo and group exhibitions throughout the United States, Europe and Japan, and is included in numerous museum collections, including the Solomon R. Guggenheim Museum in New York and the Museum of Fine Arts in Boston. Recent solo exhibitions include *Future Evolution*, Henry Art Gallery in Seattle, Washington, 2001; *Expedition*, Gorney Bravin + Lee, New York City, 2000; *The Farm*, a Creative Time billboard in New York City, 2000; and *A Recent History of the World*, Aldrich Museum of Contemporary Art, Ridgefield, Connecticut, 1999. A series of commissioned murals by Rockman are permanently installed in the Department of Fisheries, University of Washington, Seattle. Rockman teaches at Harvard University in Cambridge, Massachusetts.

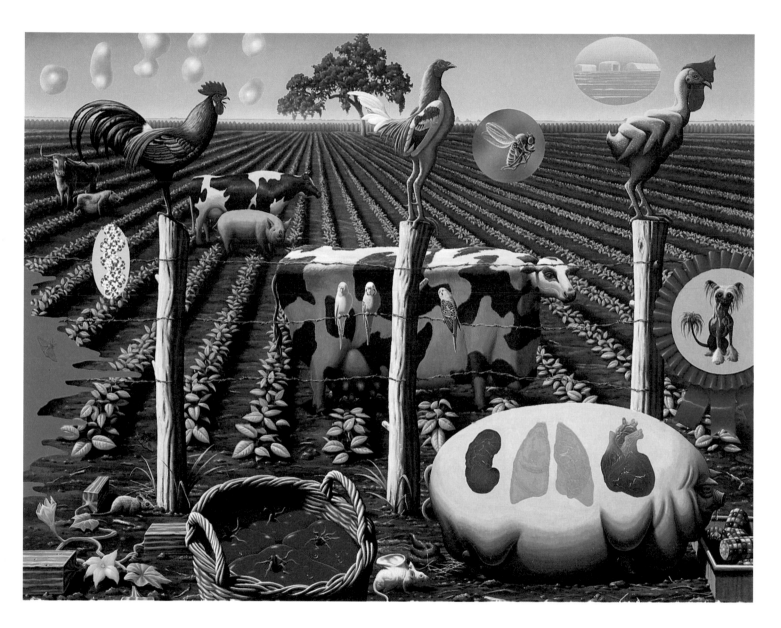

The Farm, 2000

Technology has transformed the nature of human existence. The body is no longer seen as the subject, but as an object to be monitored, modified, mutated. Genetic engineering, biological advances, and technology have made possible the conflation of human/animal and human/machine. Cyberspace is redefining the human as a bundle of information or as a source of image. The biological body exists through the mediation of images or representations and its capacities for movement and action. Hysteria, schizophrenia, transgendering are examples that demonstrate the fluidity of what is usually thought of as the constant, fixed, biological body.

Along with new technologies come new ways of understanding bodies and their

BRADLEY RUBINSTEIN

relationships to other objects and the world. Among the more crucial issues brought into question by the reconceptualization of body and thought are the binary distinctions between mind and body, subject and object, psychological and biological, gender and sex, and nature and culture.

I am primarily interested in specific and generic portraiture, while acknowledging the art historical uses of the portrait for social or political commentary, as in the work of Daumier. I am also interested in the relationship between art and science, including experiments with xenotransplantation conducted at UCLA around 1995.

I have studied the psychological phenomena of infantility patterning, retinal dilation in relation to perceived stimulus, and the historical anthropomorphizing of animals such as Vishnu and Mickey Mouse. In some of my pieces the eyes of the dog are taken from the pet of the child.

Brooklyn-based Bradley Rubenstein was recently included in the 2000 *Rounders* exhibition at Universal Concepts Unlimited, New York as well as solo exhibitions including *Dogs*, at Sara Meltzer's On View, New York City, 1998, and *Animals*, at the Kunsterhaus Hamburg, Germany, 1998 and *Figure/Ground*, at the Kunstlerhaus Bergedorf, Hamburg, Germany, 1997. Rubenstein has also participated in group shows at venues such as Central Fine Arts, New York, 1998; P.S. 122, New York, 1998; I-Space gallery, Chicago, 1998; and the Mackintosh Museum, Glasgow, Scotland, 1998.

Untitled (Boy with Puppy-Dog Eyes), 1996

What attracted me to genetic issues was the image of perfection that a thoroughbred racehorse presents to the world. Meticulous records track every thoroughbred's pedigree back more than twenty generations, making it possible to create a portrait of a horse with just the names of its predecessors. Metaphor is eliminated and an incredible level of detail is made available. The exponential function that structures pedigrees enables me to increase the scale of a piece beyond its physical dimensions: a perfect genealogical chart has no

NICOLAS RULE

spatial boundaries; it could go on forever.

This drawing enumerates all the ancestors of the 1991 Eclipse Award champion, Meadow Star. Inbreeding in the pedigree is marked by red lines. Wherever a name reappears duplicated, a red line loops back to the first occurrence of the name. The more inbred the horse, the more red the whole image becomes.

Why does the notion of selective breeding raise far fewer ethical issues than the idea of directly manipulating genes?

Born in Birmingham, England, Nicolas Rule has exhibited widely since the late 1980s in New York and Europe. Rule has recently had a solo exhibition at the Esso Gallery, New York (2000). He has participated in current group exhibitions at the Nicole Klagsbrun Gallery, New York (2001); the Holly Solomon Gallery, New York, 1999; the Galleria Milano, Milan, Italy, 2000, and the Galleria Martano, Turin, Italy, 2000. Rule lives and works in New York City.

One Horse-Meadow Star, 1992

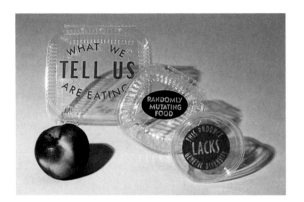

The "Terminator" seed initially sparked my interest in the science of genetically manipulated foods. The idea that a seed could be manufactured to produce a one-time harvest, only to short-circuit its own biological need for reproduction, seems diabolical. Genetic engineering is a preoccupation with destruction, allowing life forms to be defined by death.

CHRISTY RUPP

By turning living crops into intellectual property, biotechnology increases corporate control over food resources and production. Rather than alleviate world hunger, genetic manipulation is likely to exacerbate it by increasing growers' dependence on the corporate sector for seeds and the materials needed to grow them.

Christy Rupp began showing her work in the 1970s after graduating from Maryland Institute, College of Art with an MFA in 1977. Rupp's work has appeared in such varied venues over the past twenty-five years such as *The Rat Patrol* (poster campaign), lower Manhattan, 1979; *Animals Living in Cities II*, ABC NoRio, New York, 1980; *Animals and Energy*, the Staten Island Zoo, 1980, and Food, *Farming, and Foreign Policy*, Commodities Exchange, New York, 1982. Rupp has also exhibited in Documenta 7, 1982, the 1985 Biennial at the Whitney Museum of American Art, and Hallwalls Contemporary Art Center, 2000. Recent solo work include *Symbols of Survival*, Dorsky Gallery, New York, 2000; *Patentable Future: Genetically Altered Sculptures*, Frederieke Taylor Gallery, New York, 2001, and *Unnatural Histories*, Florida State University, 2001.

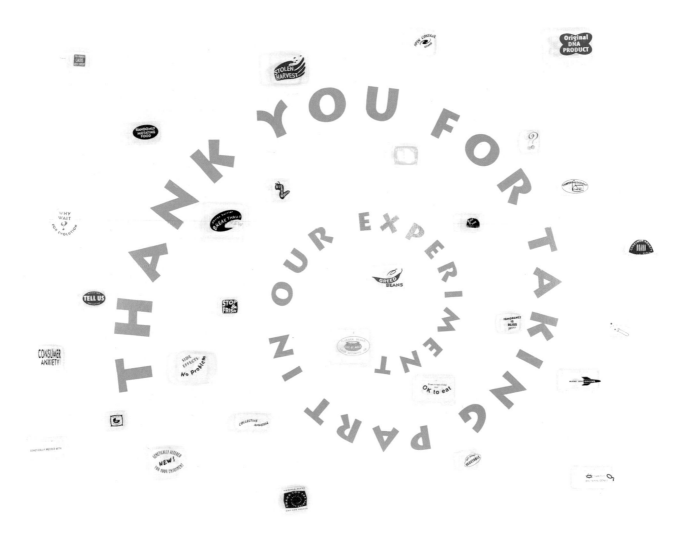

New Labels for
Genetically Engineered Food,
1999–2000

GARY SCHNEIDER

In 1996, I was approached to make work in response to the Human Genome Project. I decided to marry my obsession with biology and portraiture. My mother had just died of cancer and I wanted to know if I had a genetic predisposition. The Tumor Suppressor Gene on Chromosome 11, the specimen prepared by Dr. Dorothy Warburton, was the first of fourteen images that would become my *Genetic Self-Portrait*. I explored images harvested from my own biology, sometimes scientific, sometimes whimsical. It became, in its totality, my emotional response to the issue of privacy in the new World of Genome.

Trained in filmmaking and long interested in unorthodox portraiture, Gary Schneider began creating images that interpreted human biology the late 1980s. His numerous solo exhibitions include *Genetic Self-Portrait*, International Center of Photography, New York, 2000; *Specimen Drawings: Photographs 1987–1999*, Eleanor Barefoot Gallery, New York, 2000, and *Naming*, Artist Space, New York, 1977. Schneider's work has been part of many recent group exhibitions such as *Particle Accelerators*, Photographic Resource Center, Boston, 2000; *Reflections on the Artist: Self-Portraits and Portraits of Artists*, National Gallery of Canada, Ottawa, and *The Century of the Body: Photoworks 1900–1999*, Culturgest, Lisbon, 1999. Schneider has taught at Cooper Union in New York City, where he has lived since 1977.

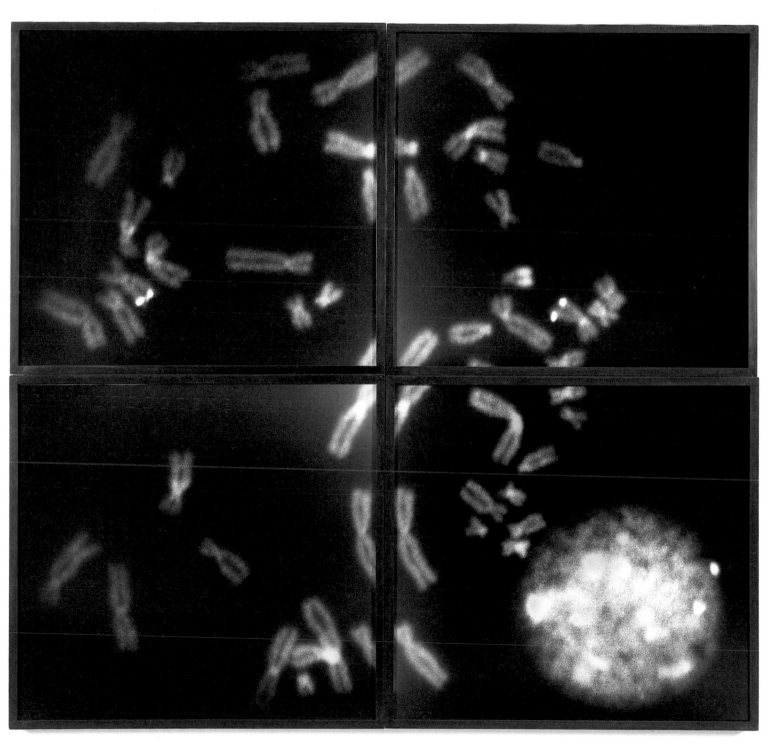

Tumor Suppressor Gene (MLL) on Chromosome 11 and on the Nucleus, 1997

LAURA STEIN

Working with life creates a way for me to explore nature and culture and their dueling influences on our existence. I like to examine the line between cultural imposition and natural development.

In the project "Animal-Vegetable," animal-shaped molds are secured over baby vegetables to shape the vegetables' formal attributes. This creates a disparity between the object's natural growth cycle and a contrived one. While growing, the vegetables exert their physical strength and frequently attempt to push through the limits of the molds. Some are too strong to be contained, but most conform to the imposed shape. There is an intense will to grow, regardless of whether they submit to or resist their formal fates. Unlike their genetically altered counterparts, individual will has an effect on their development. I view my molds as a culturally generated pressure, an applied norm, which then gets filtered into individually aestheticized interpretations.

Laura Stein graduated from California Institute of the Arts (Cal Arts) in 1985 and lives and works in New York. She recently exhibited *Aim to Please* at PS 1, Long Island, New York, 2000, *On the Inside* at the School of Museum of Fine Arts in Boston and *Animal – Vegetable* at Basilico Fine Arts in New York, 1995. Her work has been included in numerous group exhibitions including: *Subterfuge* at the Impakt Festival in Utrecht, Netherlands, 2000; *Animal Magnetism*, Bucknell Art Gallery, Bucknell University, Pennsylvania, 2000; and *Where: Allegory of Site in Contemporary Art* at the Whitney Museum of American Art in New York, 1998.

Smile Tomato, 1996
and
Green Pig + Smile on Vine, 1998

I've spent a lot of my life working and playing with computers, mostly writing software. This kind of work makes you think a lot about how to break down large, complex ideas into smaller, modular components—little ideas that you can understand, translate into an abstract language, and ultimately build back up into a new whole.

EVA SUTTON

Years ago, I was designing software for scientific instruments. These machines detected and measured the presence of radioactively tagged molecules within biological samples. While I worked with this data, I realized that the kind of modular thinking I was applying to software design was also being applied by others to biological systems, a process that was clearly not a passive endeavor. The human body and, in fact, all life forms, were being analyzed as a system of components at the molecular level, components that could be understood and manipulated. The potential consequences of this manipulation profoundly affected me. Ever since, I have been utterly fascinated by molecular biology and its offshoot, genetic engineering. What boundaries should we draw between nature and science? How much manipulation can take place before something natural becomes something artificial? "Systems" that we can imagine—be they perfect strawberries, perfect chickens, or perfect babies—can be designed and built. But what are the consequences of achieving perfection?

Eva Sutton is an artist and programmer living in New York. Her work has been featured at Aperture, SIGGRAPH, the National Center of Photography in Paris, and the on-line sites Digital Imaging Forum (www.art.uh.edu/dif), www.genomicart.org and www.pbs.org. She has lectured on issues in art and technology at Princeton, New York University, The Cooper Union, and the Hong Kong Center for the Arts. Recent exhibitions include *FOTOFEST*, Houston, Texas, 2001; *WomenTech: Women Artists Using Science and Technology*, Peninsula Fine Arts Center, Virginia, 2000 and *METAMORPHOSIS: Photography in the Electronic Age*, Aperture at FIT Museum, New York, (traveling to the Tampa Museum of Art, the Philadelphia Museum of Art, and venues in Europe and Japan) 1994–2002. Currently, Sutton is an associate professor at the Rhode Island School of Design where she has developed the curriculum in digital media and is designing a digital media graduate program.

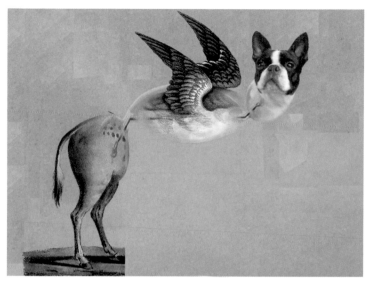
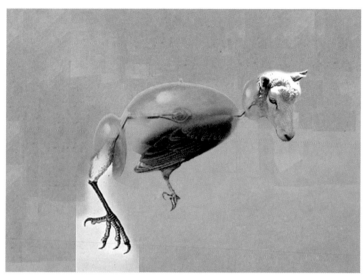
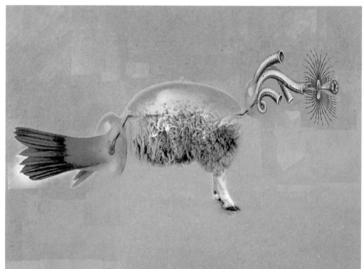
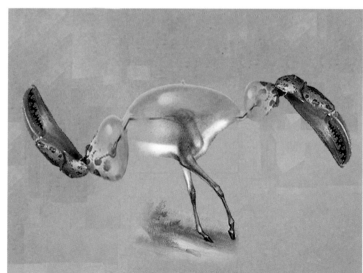

Details from **Hybrids**, 2000

When I began reading about the Human Genome Project, I was struck by the intent to determine a "genetic blueprint," first by mapping chromosomes and then by sequencing the entire gene structure of the human race. This project has gathered some

Twelve Areas of Concern and Crisis is a collection of conceptual still lifes of evidence found in –86-degree freezers containing the archival samples of Alcoholism, Alzheimer's, Bipolar Disorder, Breast Cancer, DNA Synthesis, HIV, and other research from the Human Genome Project. This freezer typology confronts the new millennium. It forces us to ask how, in the future, we will construct our individual and cultural identities.

CATHERINE WAGNER

of the most powerful minds in science to act as modern cartographers for our future. I am interested in what impact the changes that emerge from contemporary scientific research will have in our culture socially, spiritually, and physically. In my work I try to ask the kind of questions posed by philosophers, artists, ethicists, architects, and social scientists. All of these questions revolve around two central ideas: Who are we? and Who will we become?

Catherine Wagner's photographic works have been exhibited widely over the past ten years in group and solo shows at such venues as the Bibliotheque Nationale, Paris; The Smithsonian Institution, Washington, D.C.; The Museum of Fine Arts, Houston; The San Francisco Museum of Modern Art; The Museum of Modern Art, New York, and The Los Angeles County Museum of Art. Recent solo shows include: *Cross Sections*, San Jose Museum of Art, 2001; *Realism and Illusion: Catherine Wagner* *Photographs the Disney Theme Parks*, Modern Art Museum, Fort Worth, Texas, 1999; *Catherine Wagner: Selections 1978–1998*, Jack Shainman Gallery, New York, 1998, and *Art & Science: Investigating Matter*, International Center for Photography in New York, 1997.

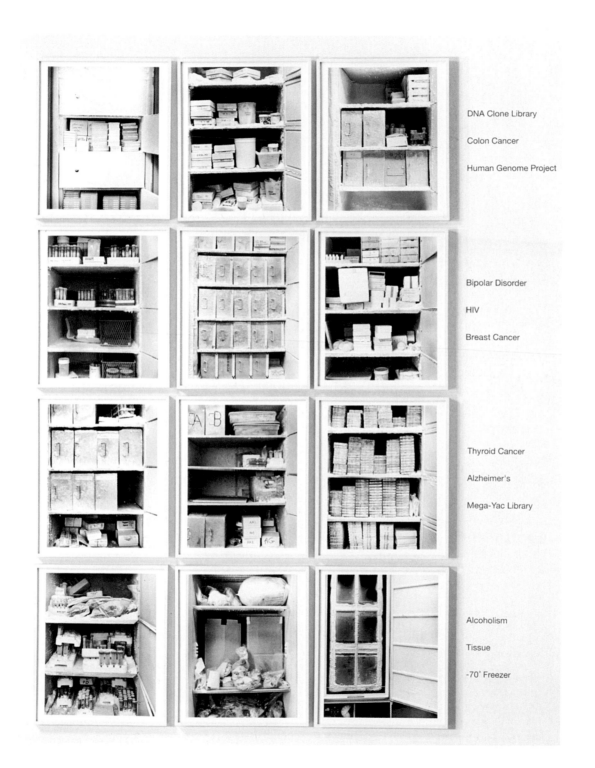

DNA Clone Library

Colon Cancer

Human Genome Project

Bipolar Disorder

HIV

Breast Cancer

Thyroid Cancer

Alzheimer's

Mega-Yac Library

Alcoholism

Tissue

-70° Freezer

Minus −86 Degree Freezers,
(Twelve Areas of Concern and Crisis),
1995

I find the interlock and interdependence amongst Science (Industry), Commerce (Celera), and the Government (the Department of Energy) fascinating. I'm almost certain that my fascination stems from my own naiveté. For instance, I believed science to be a neutral agency with truth as its ultimate goal, completely overlooking the simple fact that science involved scientists, i.e. men and women who act as a cross between God and Houdini. I'm a slow girl, so the significance of and the particularity of these three bedfellows continue to baffle me. Of course, in some small way, I understand the roll in the hay between the science, industry, and commerce, but a ménage a trois involving the Department of Energy... well, it's all just above my head. The Jefferson Suites was an attempt to sort out and make sense of the perplexing issues raised by the introduction of biotechnology and the mapping of the human genome.

CARRIE MAE WEEMS

Carrie Mae Weems earned her MFA from the University of California in San Diego in 1984 and attended the Graduate Program in Folklore at the University of California in Berkeley from 1984–87. Weems has been the subject of many solo exhibitions since the mid-1980s including most recently: *Carrie Mae Weems: The Hampton Project*, Williams College Museum of Art, Williamstown, Massachusetts, 2000; *Telling Histories: Installations by Ellen Rothenberg and Carrie Mae Weems*, Boston University Art Gallery, 1999, and *Ritual & Revolution*, DAK'ART 98: Biennale of Contemporary Art, Johannesburg, South Africa, 1997. Weems' work has been featured in group exhibitions including: *I'm Thinking of a Place*, UCLA Hammer Museum, Los Angeles, California, 2001; and *Committed to the Image: A Half Century of Black Photographers in America*, Brooklyn Museum of Art, New York, 2001. She was a Visiting Professor at Harvard University in 2001.

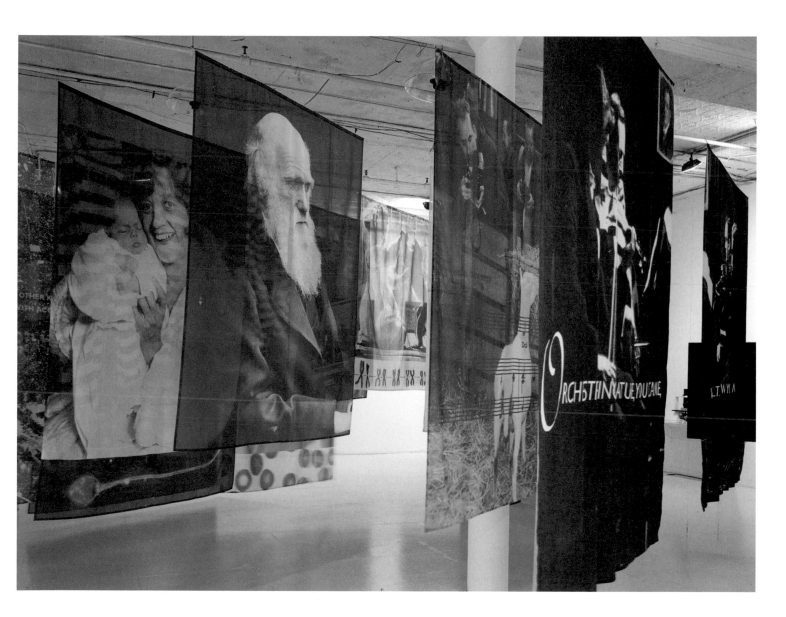

The Jefferson Suites, 1999

I've studied the historical and sociocultural aspects of science for many years. In particular, I'm fascinated by what could be called "the misunderstanding of understanding." The contemporary world of genetic science seems to encompass the full range of human passion and ideological fervor. At the same time, the popular spin on genetics portrays it as the exclusive determining characteristic of life. Taken together, these factors have combined to create a feverish crusade to manipulate and perfect life—at astounding risk.

GAIL WIGHT

Since her graduation in 1994 from the Masters Program of the San Francisco Art Institute, Gail Wight has shown widely in San Francisco and the Bay Area.

Wight was recently included in the 1999 Ars Electronica. That same year, she exhibited at Artspace in Woolloomooloo, Australia, the Physics Room in Christchurch, New Zealand, and the Pittsburgh Center for the Arts in Pennsylvania. Her many solo shows include a mixed media installation, *Hereditary Allegories: A Study in Genetics*, at the Capp Street Project in San Francisco, California, 1995, and the performance *Floraphobia*, at the Habitat Institute, Belmont, Massachusetts.

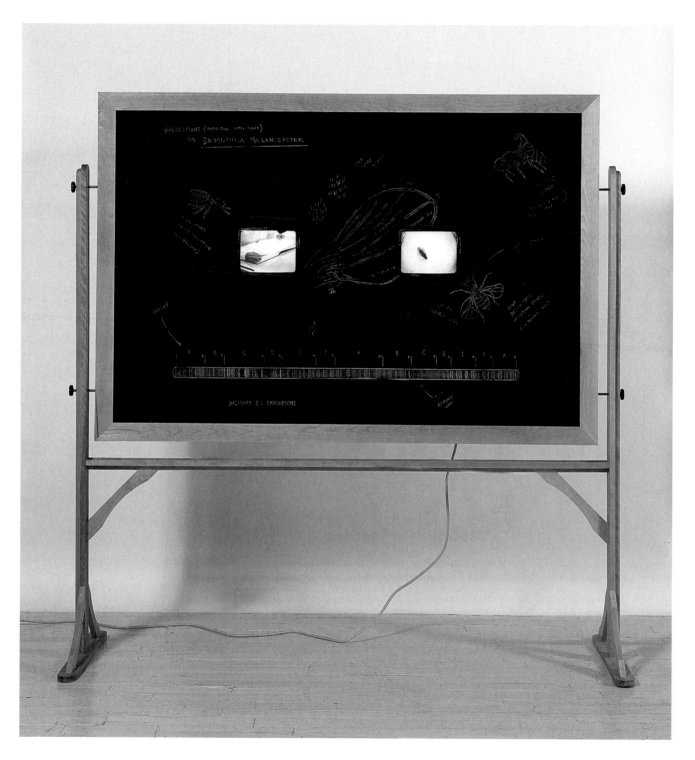

Future Flight, 2000

This sculpture is a device that unrolls an image of the cave paintings at Lascaux—one of the earliest representations, made about 15,000 years ago—and turns it into the abstract code of ancient human DNA. The DNA sequences were taken from ancient human bones and were obtained from the DNA Learning Center at Cold Spring Harbor.

JANET ZWEIG
AND LAURA BERGMAN

Janet Zweig earned her MFA at The Visual Studies Workshop at the State University of New York in Rochester, New York in 1981. Zweig was a visiting critic at Yale University from 1991–2000 and has been a faculty member of the Rhode Island School of Design since 1982. Recent work has been included in *Beyond Technology: Working in Brooklyn* at the Brooklyn Museum of Art, New York, 1999, and *In Three Dimensions: Women Sculptors of the '90s*, Snug Harbor Cultural Center, Staten Island, New York, 1995. Zweig has received numerous awards and fellowships including the New York Foundation for the Arts Fellowship, 1999, the National Endowment for the Arts Visual Arts Fellowship: Sculpture, 1994, The Rome Prize Fellowship, American Academy in Rome, 1991–92, and the National Studio Program at PS1 Museum in Long Island City, New York, 1990–91.

Laura Bergman is a painter, gilder, and former pastry chef.

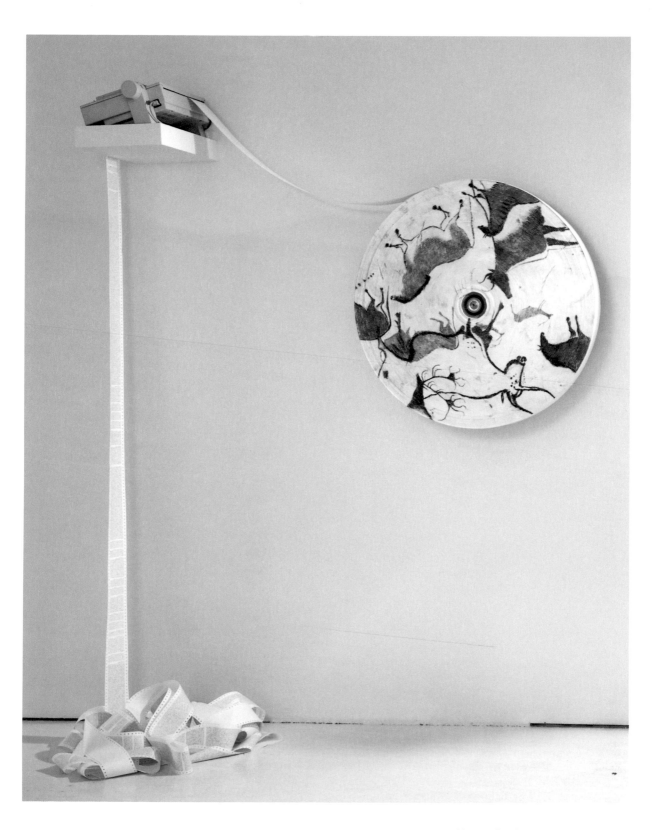

Abstraction Device,
(machine to find the earliest
creativity gene), 2000

Installation view
Exit Art, New York

Marvin Heiferman and **Carole Kismaric** are co-founders of the New York-based company Lookout that develops exhibitions, packages books, and strategizes programming for cultural institutions. Lookout exhibitions address social and cultural issues, and include *Paradise Now: Picturing the Genetic Revolution* (2000), *Fame After Photography* (1999), *To The Rescue: Eight Artists in An Archive* (1999), and *Talking Pictures: People Speak About the Photographs that Speak to Them* (1994). Their books on popular culture include *The Art of the X Files*, (1998), *Growing Up with Dick and Jane: Living and Learning the American Dream* (1996), *Cinderella and Little Red Riding Hood* (1993, in collaboration with William Wegman), and *I'm So Happy* (1990). Lookout has also packaged monographic books on the art of John Coplans, Dennis Oppenheim, and Jack Smith. Heiferman and Kismaric are currently writing a non-fiction book about celebrity's impact on American culture, scheduled for publication by Pocket Books in 2003.

Prior to forming Lookout, **Heiferman** organized more than 100 photography exhibitions for Light Gallery and Castelli Graphics. The producer of Nan Goldin's multi-media *Ballad of Sexual Dependency* (1986), he also curated museum exhibitions including *Image World* (Whitney Museum of American Art, 1989, with Lisa Phillips), *The Real Big Picture* (The Queens Museum, 1985), T*he Family of Man, 1954–1984* (P.S. 1, 1984), and *Still Life* (The Whitney Museum of American Art, 1982, with Diane Keaton). Heiferman has written extensively on photography and art issues for museum catalogs and for publications including Artforum and BOMB.

Kismaric was one of the original editors of Time-Life's Library of Photography, editing among the books in the series, *The Art of Photography and Documentary Photography*. With John Szarkowski, she co-directed the exhibition *From the Picture Press* at the Museum of Modern Art in 1973. As editorial director of Aperture, she edited the quarterly magazine and developed over fifty books for the foundation, including *Diane Arbus, Magazine Works*, *Lisette Model*, *Telex Iran* (by Gilles Peress), *Chauncey Hare's Interior America*, *Robert Adams, From the Missouri West* and *Beauty in Photography*, among others. She developed the publishing program at P.S. 1 Contemporary Art Center. She is the author of several children's books and has written numerous articles for magazines in the United States and in Europe.

Mike Fortun is Assistant Professor of Science and Technology at Rensselaer Polytechnic Institute. He is the author of many papers and lectures and the books, *Muddling Through: Pursuing Science and Truths in the Twenty-first Century* (co-authored with Herbert J. Bernstein), and *The Practices of Human Genetics: Sociology of the Sciences Yearbook* (co-edited with Everett Medelsohn). His recent research is based on the genomic debate in Iceland, in particular the discussion around deCODE Genetics, a company licensed to create the nation's healthcare database. He was awarded a fellowship at the Institute for Advanced Study in Princeton, New Jersey in 2000, and will use his field research in Iceland as the basis for a forthcoming book, *Promising Genomics*.

Ricki Lewis is the author of *Life*, an introductory biology text; *Human Genetics: Concepts and Applications*; co-author of two human anatomy and physiology textbooks; and the author of *Discovery: Windows on the Life Sciences*, an essay collection about research and the nature of scientific investigation. Lewis is a Contributing Editor to *The Scientist*, and has published more than 3,000 articles in a variety of magazines. She is an adjunct faculty member at Miami University and the University at Albany, and has served as a genetic counselor in Schenectady, New York since 1984.

Frank Moore is an artist and critic. His first one person show, *The Birds and the Bees* was held at the Clocktower in New York in 1983 and was followed by several solo exhibitions at Paula Allen Gallery and Sperone Westwater in New York. Moore's paintings have been included in many group exhibitions including The 1995 Biennial Exhibition at the Whitney Museum of American Art. He has collaborated with choreographers and filmmakers in performances at the Dance Theater Workshop, Jacobs Pillow Dance Festival, and Lincoln Center, among others. Moore is also an activist and continues to work on many health and environmental issues.

Bernard Possidente received his BA in Biology at Wesleyan University in 1976 and his PhD in Genetics at the University of Iowa in 1981. He joined the faculty of Skidmore College in 1983 and served as chair of the Biology department from 1990–1994. Currently professor of biology at Skidmore, Possidente has been a collaborator and principal investigator on many projects and teaches courses in genetics, human genetics, history of genetics and on biological clocks. His research centers on the study of quantitative genetic analysis of biological clock function in mouse and fruitfly model systems and the genetic analysis of behavioral adaptations.

10,000 to 5,000 Years Ago Agriculture begins in the Yellow River region of China (rice and millet) and in the Fertile Crescent (grasses, lentils and chickpeas). Selective breeding genetically modifies crops and animals for human use.

350 B.C. Aristotle writes 'The Generation of Animals' and proposes that the male parent contributes the plan and the female parent contributes the raw material for generation of offspring.

1600 Spontaneous generation of living organisms from non-living material is commonly accepted as an explanation for the origin of simple organisms. "Emboitment" theories are also widely accepted, proposing that a tiny pre-formed miniature organism resides inside each sperm or egg cell, and grows larger during development, with another inside that one, and another inside that etc. in the fashion of Russian dolls.

1840 The use of microscopes establishes the cell theory, demonstrated the existence of microscopic organisms, and reveals transformations of fertilized eggs progressing through developmental stages, generating embryonic stages preceding the appearance of adult structures. These observations argue against spontaneous generation preformationist theories of heredity and development.

1859 Darwin publishes his theory on the origin of species by natural selection, but can't satisfactorily explain the hereditary mechanism mediating natural selection.

1866 Gregor Mendel publishes his observations on the inheritance of variations in strains of peas. He concludes that paired hereditary factors, now called genes, are inherited in predictable patterns underlying the variation in the characteristics of the pea plants. These hereditary patterns identify the existence of genes, and are known as "Mendel's Laws". Mendel's discoveries are largely ignored by the scientific community until 1900.

1869 Friedrich Miescher isolates a substance, nuclein, from white blood cells on soiled bandages. Miescher, a scientist trying to characterize the biochemistry of cells, had identified the substance that would later be recognized to contain DNA.

1900 Three botanists (Hugo DeVries, Karl Correns, and Eric Tschermak) independently rediscover Mendel's laws of inheritance. This leads to the discovery that Mendel's laws apply widely to numerous traits in many plant and animal species.

1902 Archibald Garrod, a physician, links human hereditary disorders to protein abnormalities and to Mendelian patterns of heredity. He describes these as "inborn errors of metabolism" and in doing so is the first to apply Mendel's laws to humans and identifies the first human genetic traits.

Walter Sutton, cytologist, demonstrates that **1903** chromosomes are paired and carry Mendelian "characters." This observation associates Mendelian hereditary factors with specific cellular structures (chromosomes) which had been observed but have no known function.

Theodor Boveri, cytologist, shows that chro- **1903** mosomes do not disappear between cell divisions, but are always present. Chromosomes are usually only visible through a microscope during cell division when they shorten and thicken. Boveri's discovery that chromosomes are present all the time supports the idea that they are the physical location of genes in a cell.

William Bateson reconfirms Mendel's disco- **1904** very that predictable patterns of heredity correspond to the existence of hereditary elements (e.g. genes), and names the study of inheritance "genetics."

Mathematician G.H. Hardy and physician W. Weinberg independently derive a simple algebraic formula that explains the actions of genes in groups of people. This begins to provide a theoretical basis for extending Mendel's laws of heredity from individuals to populations, and applying Mendelian genetics to Darwin's theory of evolution to understand the origin of random mutations and how natural selection results in hereditary adaptations.

Thomas Hunt Morgan, embryologist, disco- **1910** vers sex chromosomes in fruitflies, a single chromosome pair that differs between males and females. This discovery establishes a genetic basis for biological sex differences and for "sex-linked" genetic factors (located on the sex chromosomes) that are inherited in a different pattern by males versus females.

Morgan, and his student Alfred Sturtevant, **1913** create the first genetic map, showing the locations of six sex-linked genes on a fruitfly chromosome. This feat supports the idea that there are individual hereditary elements, linked together on chromosomes, with a characteristic location for each gene, allowing chromosome maps of genetic information to be constructed for each species.

Herman Mueller demonstrates that genetic **1927** mutations can be induced by exposure to X-rays. This provided a useful tool for genetic research, and also provided new insights into the mechanisms that cause mutations.

A SHORT HISTORY OF GENETICS AND GENOMICS

RICKI LEWIS with **BERNARD POSSIDENTE**

1928 Frederick Griffith, medical micro-biologist, transfers ability to cause deadly pneumonia in lab mice from one type of bacteria to another. He proposes that the hereditary ability of bacteria to cause pneumonia can be altered by a "transforming factor." This research provides an experimental system for studying the biochemical basis of heredity in bacteria (see 1944, below).

1929 Phoebus Levene discovers that deoxyribose (a sugar molecule), a phosphate molecule, and four types of nucleic acid "bases" form the molecular building blocks of the structure of DNA. They are called nucleotides. At this time DNA is not recognized as the molecular structure of genes, but is recognized to exist in the nucleus of cells as part of the structure of chromosomes. Levene also recognizes that the four types of nucleotides each contain exactly the same phosphate and sugar molecule, but have a different nucleic acid base. Later (see 1953) the four nucleotides will be recognized as the "letters" that carry genetic information in a genetic code, but until that time most scientists believe that nucleic acid is too simple a molecule to carry genetic information and focused on the more complex proteins in the chromosomes as a candidate molecular structure for genes.

1929 Thomas Painter, cytologist, publishes the first sketches of human chromosomes, which appear to number forty-eight. Although slightly in error (see 1956) this is the first estimate of the number of human chromosomes.

1944 Oswald Avery, Colin MacLeod, and Maclyn McCarty show that Griffith's "transforming factor" (see 1928) is DNA, and not protein. They use enzymes to destroy bacterial proteins, and shows that the hereditary transformation from harmless to virulent pneumonia still occurr. When they enzymatically destroy the bacteria's DNA however, the hereditary transformation is blocked. This result supported the idea that DNA, not protein is the molecular basis for genetic information.

1949 Linus Pauling, a physical chemist interested in heredity, proposes that the disease sickle cell anemia might be caused by a defect in the molecular structure of protein. This sets the stage for later work (see 1956) supporting the idea that genetic information is used by cells to direct the synthesis of protein, such that a change in genetic information (e.g. mutation) can directly cause a change in a protein, this, in turn, explains hereditary genetic disorders such as sickle cell anemia.

1950 Alfred Hershey and Martha Chase, biochemists, show that when virus particles that infect bacteria are shaken off (by mixing them in a Waring blender) it is the viral DNA, and not the viral protein, that is left behind inside the bacteria to direct the replication of new viruses that kill the host cell. This experiment provided further evidence that it is DNA, not protein, that carries genetic information.

Erwin Chargaff shows that DNA contains equal **1952** amounts of the nitrogenous bases adenine and thymine, and equal amounts of guanine and cytosine, the four nucleotide components of DNA (see 1929). These four nucleotides, now commonly symbolized "A,T,G and C" as the four "letters" of the genetic code, exist in DNA. There is an A for every T, and a G for every C. Chargaff also shows that while the ratio of A+T to G+C letters varies among different species, it is constant among different cell types within each species. While it still seems as though the molecular structure of DNA is far too simple to code for genetic information, it is intriguing that the proportions of the four nucleotides are specific to each species, and that there is a one to one ratio of A to T letters and of G to C letters in all species.

Maurice Wilkins and Rosalind Franklin obtain **1952** X-ray images of DNA crystals, revealing a regular repeating unit of molecular building blocks that correspond to the nucleotide components of DNA. A single DNA molecule is too small to view directly with a light microscope because it is much smaller than the wavelength of light. A crystal, however, contains many individual identical molecules in a regular repeating structure. Since X-rays have a much shorter wavelength than visible light, beaming X-rays through the crystal creates an image. Patterns in the X-ray image reflect patterns in the molecular structure of the crystal, making it possible to reconstruct features of the molecular structure that can produce the observed X-ray image pattern. Although not a direct image, this method can reveal some characteristics of three-dimensional molecular structure if a pure crystal can be obtained.

James Watson and Francis Crick deduce the **1953** three-dimensional structure of DNA. Relying heavily on X-ray crystallography data (see 1952) and the work of Chargaff (see 1952) Watson and Crick propose a three-dimensional molecular structure for DNA. Their model makes it possible to understand the function of genes (mutation, carrying hereditary information that directs the synthesis of proteins, and replication) at a molecular level, and makes a convincing argument that genetic information is carried by DNA, not protein. Watson and Crick propose that the molecular structure of DNA representing genes consists of two strings of nucleotides connected across like a ladder. Each step contains either a G-C pair of letters or an A-T pair, accounting for Chargaff's observation (see 1952) that there is an A for every T and a G for every C in DNA. They also propose that this double-stranded ladder is twisted around itself into a "double helix" in a spiral staircase fashion. The particular sequence of nucleotide pairs up and down the double helix, they reason, constitute the genetic information and changes in the sequence represent mutation. They also propose that this structure immediately suggests a mechanism for replication: unzipping the two strands

from end to end and replacing the missing letters in each pair with the complementary partner (e.g. A with T for one complementary pair, and G with C for the other). This mechanism, named "semi-conservative replication" creates two identical copies of the original molecule, with one strand completely conserved, and the other completely new (see 1958).

1956 Albert Levan, Joe-Hin Tijo and others determine that human chromosomes number forty-six. Determining the normal number of human chromosomes, and improving upon methods for staining and viewing them microscopically, initiates our ability to directly analyze chromosome number and structure in medical diagnosis of genetic disorders associated with altered chromosome morphology, (see 1959).

1956 Vernon Ingram identifies the single DNA base difference between normal and sickle-cell hemoglobin. This finding associates the mutation of a single letter in the DNA genetic code with the alteration of a single amino acid in the structure of a protein, to cause an hereditary medical disorder. This causal relationship between changes in DNA changes in protein structure and genetic disorders is the basis for current efforts to comprehensively map genetic variations relevant to human health.

1958 Mathew Meselson and F.W. Stahl experimentally demonstrate the semi-conservative nature of DNA replication. They show that a double helix locally unwinds at several points and knits a new strand along each half of the old strand (see 1953). Meselson and Stahl use radioactivity to label each strand of the DNA in bacteria differentially and show that one strand is conserved intact, and combined with one newly synthesized strand when the DNA replicated, as predicted by Watson and Crick's replication model.

1959 First human chromosome abnormality is identified. Down's syndrome is shown to have an extra chromosome, showing that it is a genetic disorder that can be diagnosed by direct cytological examination of the chromosomes.

1961 to 1963 Francis Crick, Marshall Nirenberg, George Gamow, and other scientists conduct experiments that reveal a direct correspondence between DNA nucleotide sequences and the sequence of the amino acid building blocks of proteins. They determine that the four nucleotide letters can be combined into sixty-four different triplets (e.g. three letter triplets with four choices for each letter allows 4x4x4=64 unique triplets). The triplets "code" for cellular instructions that determine the amino acid structure of proteins. Cellular organelles, called ribosomes, read a sequence of genetic code three letters at a time and link together amino acid building blocks of proteins specified by the triplets to construct a specific protein. One of the sixty-four triplets is read as a "start" instruction and also specifies the amino acid methionine, three represent "stop", and in between

the other sixty triplets specify, with a number of synonyms, the nineteen other amino acids used by all cells to build proteins. The sixty-four triplets of nucleotides that can be coded in the DNA, copied with each cell division, occasionally mutated, and read by the cell to direct protein synthesis, constitute the universal genetic code for all cells and viruses.

Smith, Wilcox and others isolate "restriction" **1968** enzymes from bacteria, that contain viral infections by cutting the DNA of viral chromosomes. The restriction enzymes are shown to cut DNA at specific sequences, leaving single-stranded ends that can be reconnected to other pieces of DNA cut by the same species of restriction enzyme. The restriction enzyme's ability to cut DNA sequences at specific sequences and to form "sticky ends" is what made recombinant DNA methods possible and established modern genetic engineering technology, (see 1972).

Paul Berg and colleagues, using restriction **1972** enzymes to cut and splice DNA fragments from different organisms, create the first molecule of recombinant DNA, ushering in the era of genetic engineering.

Frederick Sanger, Allan Maxam, and Walter **1977** Gilbert independently develop ways to sequence DNA. These methods allow, for the first time, the sequence of letters from fragments of DNA to be read biochemically. This allows scientists to read and translate the genetic information in DNA to determine the protein structure coded by a gene.

Map of human genome is published showing **1980** RFLP markers, by Mark Skolnick, Ray White, David Botstein, and Ronald Davis. RFLP (restriction fragment length polymorphism) markers combine genetic mapping (see 1913), the use of restriction enzymes to cut DNA into fragments (see 1968), and DNA sequencing (see 1977) to create the first map for human chromosomes, identifying the location of DNA sequences that can be cut with a specific restriction enzyme in some people, but not in others (this represents a human genetic map of polymorphisms for DNA sequence differences). The significance of this map allows for other genetic polymorphisms, of medical importance, to be mapped by determining whether or not they are linked (and therefore inherited with) the RFLPs.

U.S. Supreme Court decision allows gene-**1980** tically modified organisms to be patented. The first patent is awarded to the General Electric Company for a bacterium designed to help clean up oil spills.

Akiyoshi Wada pioneers automated DNA se-**1982** quencing, a technique that will become crucial to the genome project. The ability to read DNA sequences biochemically (see 1977) will be enhanced dramatically by automating the procedure, so far limited to a few hundred letters of genetic code per day, per researcher (see 1986).

1982 The Eli Lilly pharmaceutical company markets the first genetically engineered drug: a form of human insulin called "Humulin," grown in genetically modified bacteria.

1983 Huntington disease marker is identified. By linking the inheritance of Huntington's disease with an RFLP (see 1980) using genetic engineering methods (see 1972) and sequencing (see 1977) it is possible to identify a relatively small region of human chromosome four physically linked to a mutation causing Huntington's disease. The next step will be to determine the DNA sequence throughout this region of the body in order to identify the Huntington locus and specific mutation responsible for the disorder (see 1993).

1985 Kary Mullis invents the polymerase chain reaction (PCR), which amplifies select pieces of DNA. Up until this point, it is necessary to isolate large amounts of DNA from original sources to have enough to analyze biochemically. Mullis, using adaptations of cellular mechanisms of semi-conservative replication (see 1958), invents a method for replicating millions of copies of a DNA sequence from as little as a single original copy. This invention is the genetic equivalent of a printing press, allowing any trace amount of DNA to be amplified into enough copies for biochemical analysis and manipulation, this greatly facilitates research, medical testing, and forensic applications of molecular genetics.

1986 Human genome project is discussed in United Kingdom by Sydney Brenner at U.S. Department of Energy meetings in Santa Fe, and at Cold Spring Harbor Laboratory in New York. A human genome project is described as an effort to determine the DNA se-quence of the entire human genome. Renato Dulbecco, molecular biologist, publishes a paper in the journal *SCIENCE*, discussing the potential for a successful genome project. The article stimulates serious discussion about the feasibility and value of the project.

1986 Leroy Hood and Lloyd Smith develop first automated DNA sequencer produced commercially by Applied Biosystems a year later. This is a critical advance in efforts to sequence the human genome, and other genomes, which contain anywhere from a few million nucleotide letters (bacteria) to billions (some plants and animals). Automated sequencers allow DNA sequencing labs to decode millions, instead of thousands, of letters of genetic code per day.

1987 The initiative to sequence the human genome officially begins under the direction of the U.S. Department of Energy.

1988 U.S. National Institutes of Health (NIH) take over the human genome project, establishing the Office of Human Genome Research, with James Watson as director.

1989 National Center for Human Genome Research is established by NIH to conduct the Human Genome Project. A joint committee from NIH and DOE found the Committee on Ethical, Social, and Legal Issues related to the genome project, at Watson's request, and assign it 5 percent of the genome project funds annually.

Cystic fibrosis gene is identified. 1989 Identification of the cystic fibrosis locus and its DNA sequence allows a diagnostic genetic test for cystic fibrosis gene mutations to be developed, and initiates molecular genetic research aimed at producing effective treatment and a potential cure for cystic fibrosis.

Government-funded work begins on preli- 1990 minary genetic maps of the genomes for humans and four model organism genomes. The human genome project is conceived from the beginning as one including model organisms used in research that are thought to share many genes with humans, and as "practice" smaller genomes, for developing the ex-pertise to succeed in sequencing the human genome.

BLAST algorithm (e.g. BLAST: Basic Local 1990 Alignment Search Tool computer program) is developed for aligning DNA sequences. The program aligns a sequence of interest against other sequences for comparison in matching sequences for different degrees of similarity. Once DNA sequences begin to accumulate in DNA databases from humans and other species, computer programs designed to facilitate the systematic analysis and comparison of these DNA sequences across different databases need to be developed, giving rise to the new discipline of bioinformatics.

First gene therapy, on a four-year-old girl with 1990 an inherited immune deficiency disorder. Ashanti DaSilva, born with Adenine Deaminase deficiency that fatally compromises immune system function, receives the first human gene therapy treatment at the National Institutes of Health, in addition to conventional treatments in case the gene therapy does not work. Today, she leads a relatively normal life.

J. Craig Venter, at NIH, invents expressed 1991 sequence tag (EST) technology, which identifies genes that are transcribed and translated into protein from partial sequences. ESTs are particularly useful for analyzing simultaneous expression of many genes. When a protein is synthesized from genetic instructions, a cell makes a copy of the genetic information from the original gene (transcription) and then reads the genetic code instructions to assemble the protein (translation) (see 1961–1963). The EST method can identify all of the DNA sequences in a cell that are being copied for use in directing protein synthesis by identifying a small piece of each genetic "message" which can be sequenced and mapped to its origin in the genome. This is one of the key new technologies that have moves genetic analysis from the study of one gene at a time (genetics) to the study of all of the genetic information expressed in a cell (genomics).

1991 Fighting over patenting DNA begins in earnest. The rapid identification of numerous human DNA sequences by the genome project and private biotech companies results in a race to claim patent rights associated with specific genes, including conflicting claims, debate over the criteria for granting patents on DNA sequences, and the scope of patents claimed and granted.

1992 Watson and Venter leave NIH. Watson resigns as director of the Human Genome Project to protest NIH's decision to patent its human gene sequences. Venter resigns to found The Institute for Genomic Research (TIGR) as a non-profit institute to undertake the sequencing of the genomes of bacteria and other model organisms. This is significant because eventually, Venter also founds a private company to successfully undertake a private human genome project parallel with the public one (see 1998). Wellcome Trust, a foundation supporting biomedical research in Britain, joins the NIH public genome project and begins building the Sanger Research Center in England which ultimately sequences about one-third of the human genome.

1992 California Institute of Technology develops a bacterial artificial chromosome (BAC) which the public genome project adopts as a method for storing and reproducing large pieces of human DNA for mapping, sequencing, and assembling into a finished human genome sequence.

1992 Preliminary physical and genetic maps (not sequences) of the human genome are published. Essentially an update of the RFLP human genome map published earlier (see 1980), but much more detailed, it includes many more known genes and genetic markers. These maps facilitated the search for additional genes, and help in the development of strategies for dividing up the human genome for later sequencing in the genome project.

1993 Huntington disease gene is identified, ending a decade-long search following linkage to an RFLP marker (see 1983). Diagnostic genetic tests for carrying the mutation, and new avenues of basic research aimed at prevention, treatment and possible cure for the disease are now possible.

1993 Francis Collins, from NIH, takes over as director of the Human Genome Project. Completion is predicted for the year 2005. The Sanger Center in England opens and begins contributing to the public genome project (see 1992), along with research centers in Germany, France, Japan, and other countries.

1995 Craig Venter, Claire Fraser, Hamilton Smith, and others at The Institute for Genomic Research (TIGR: see 1992) publish the first complete genome sequence for any organism: the bacterium Haemophilus influenzae, with just under two million genetic letters and approximately 1,000 recognizable genes. This allows analysis at the DNA and protein level of all of the genetic information in this pathogenic organism, and also demonstrates the feasibility and utility of genome projects.

Patrick Brown and colleagues at Stanford University invent DNA microarray (DNAchip) technology. **1995** This technology, which places DNA sequences on a small chip uses technology adapted from the manufacture of computer chips, modified ink-jet printers, and other methods, can be used to simultaneously analyze genetic information representing thousands of genes. An array of genes on the chip, with each DNA sequence in a known location, can be used to assay whether or not that genetic information is present in any cell, organism, tissue, or functional state of an organism. This technology is already widely used to characterize gene expression patterns in different human tissues in various types of developmental stages (e.g. gene expression in stem cells versus differentiated cells) and disease states (e.g. cancer cells versus health tissue), and is also being used to simultaneously carry out thousands of diagnostic tests for genetic mutations.

International Human Genome Project consortium sets rules at a Bermuda meeting to facilitate **1996** cooperation and public release of data. The countries involved in the now international public genome project agree to make the human genome sequence public sequence by sequence, as the project progresses. This agreement insures that the public will have immediate and direct access, on the internet, to the first human genome sequence.

The yeast genome, containing approximately **1996** 6,000 genes and fourteen million nucleotides, is sequenced. This is the first non-bacterial genome sequenced. About a third of the yeast genes are shown to have matching sequences in the human genome, thereby adding to the value of yeast as a model organism for studying genes of importance to humans and all non-bacterial organisms.

Afffymetrix corporation is the first to commercialize DNAchips (see 1995), facilitating the use of **1996** DNA microarray analysis in basic research and biotechnology laboratories.

The genome of the bacterium E. coli, a classic **1997** model organism for studying microbiological and molecular genetic mechanisms, and a natural symbiont in the human digestive tract, is completely sequenced, revealing about 4,600 genes among about four and one-half million nucleotides.

NIH begins a parallel project to the Human **1998** Genome Sequence effort, designed to map single nucleotide polymorphism (SNP) sites in the human genome. SNP's identify map locations where a mutation in a single letter of the genetic code can be identified in the human population. Some of the key objec-

tives of the SNP database project are to characterize the extent of genetic variation in the human species and to determine which variations are medically significant by testing them for association with human medical disorders.

1998 Craig Venter, founder of The Institute for Genomic Research (TIGR: see 1992) establishes Celera, a private corporation, and predicts that Celera will sequence the human genome in three years, at a much lower cost than the public genome project.

1998 The genome of a nematode worm Caenorhabditis elegans, a key model organism for investigating genetic regulation of development, is sequenced, revealing approximately 18,000 genes among some 100 million nucleotides of DNA sequence. At this time, the human genome is known to consist of just over three billion nucleotides, with an estimated number of genes ranging from about 50,000 to well over 100,000. The C. elegans genome project begins to approach the scale of the human genome project and provides another multicellular animal genome for comparative analysis.

1999 Jesse Gelsinger, an eighteen year-old with a genetic disorder affecting liver metabolism, dies from an immune reaction to a gene therapy treatment. This tragic event slows gene therapy applications and results in greater scrutiny and caution toward the growing number of gene therapy research trials.

1999 The Wellcome Trust (see 1992) and ten private pharmaceutical and biotechnology companies, undertake an SNP mapping project (see 1998) parallel to a similar effort by the National Institutes of Health.

1999 The first complete sequence of a human chromosome (number 22) is completed by the public genome project and is published. This step indicates that the genome project is proceeding ahead of schedule, and also shows a surprisingly small number of genes (about 300) relative to the anticipated 100,000 or so for all twenty-four human chromosomes (twenty-two chromosomes called autosomes shared equally by males and females, plus the X-chromosome which is paired in females but occurs in a single copy in males, plus the Y-chromosome that is unique to males).

2000 Celera sequences the genome of the fruitfly (Drosophila melanogaster), identifying approximately 13,000 genes among 170 million nucleotides. This step greatly en-hances the use of fruitflies as a model organism in genetics, shows matching sequences to many human genes already identified with medical genetic disorders, and demonstrates that a fly with millions of neurons and complex behavior has fewer genes then a microscopic nematode worm.

2000 The public and private genome projects become increasingly competitive, as concerns about Celera patenting human genes ahead of the public genome

project's completion arise, and competition between the two projects becomes more public. The competition speeds up both projects however, as Celera makes use of already published public data, and the public genome project realizes, based on Celera's rapid progress, that they can complete a reasonable draft of the human genome sequence about as quickly as Celera.

The two genome projects (public and private) jointly announce the completion of drafts of the human genome sequence on June 26th. Although both are ready to announce the completion of a draft genome sequence months earlier, June 26th is the first available date on the White House calendar. The joint announcement is, however, designed to minimize the competitive atmosphere surrounding the "race" between the two projects to finish first, and sets the stage for future cooperation and complementary analysis between the two genome projects.

2000 First plant genome sequenced (Arabidopsis-thaliana) from the mustard family. The success of this first genome project brings sequencing technology, applied first to animals in the context of biomedical research objectives, to plants, as well for basic research in plant biology and potential applications to agriculture. The Arabidopsis genome consists of about 100 million nucleotides, and approximately 20,000 genes, indicating that at the molecular genetic level, plant and animal genomes are about equally complex.

2000 "Golden rice," a genetically engineered strain of rice manufactures its own vitamin A. Golden rice is created by Ingo Potrykus, plant geneticist, and his colleagues to help alleviate severe health problems in many areas of the world caused by vitamin A deficiency.

2001 In mid-February, the journal SCIENCE publishes an analysis of the Celera Human Genome Project, and the journal NATURE publishes an analysis of the public Human Genome Project. The public se-quence is placed on the internet, and the Celera sequence is available by commercial license. Both journals publish summaries of the initial analysis of the human genome DNA sequence, and also prove to be useful as complementary replications of the human genome project that verify and complement each other's findings. Both revealed a surprisingly small number of human genes, estimated jointly at about 30,000 to 35,000, barely more than a worm, fruitfly, or plant. Both show that only about 2 percent of our DNA actually codes for amino acid sequences of proteins, and both identify many sequences of unknown function and variable length present in multiple copies making up approximately half the genome. The official publication of the Human Genome initiates a much more challenging era of genomic and post-genomic analysis devoted to understanding the functional significance of our genome and its organization, and the consequences of mutations that can change it.

Anderson, W. F. 1992. "Human gene therapy." *Science*, vol. 256, pp. 808–813. Gene therapy enjoyed nearly a decade of slow but steady success, until a tragic failure in 1999.

Beale, D. and H. Lehmann. 1965. "Abnormal hemoglobins and the genetic code." *Nature*, vol. 207, pp. 259–261. The first inherited disorder to be understood at the molecular and cellular levels was sickle cell disease.

Botstein, D. et al., 1980. "Construction of a genetic linkage map in man using restriction fragment length polymorphisms." *American Journal of Human Genetics*, vol. 32, p. 314–331. Before there were genome sequences, there were RFLP marker maps—signposts, of sorts.

Bouchard, T. J. et al., 1990. "Sources of human psychological differences: the Minnesota study of twins reared apart." *Science*, vol. 258, pp. 223-228. Much of what we know about genes versus the environment comes from these studies of Minnesota twins.

Butler, Declan. October 4, 2001. "Mouse genome roars ahead with new map." *Nature*. www. nature. com/cgi-taf/ Dyna Page.taf?file=/ nature/journal/v413/ n6855/ full/413444a0_ fs.html. The public-domain effort to sequence the mouse genome is set to accelerate, following the completion of a physical map of the genome.

Campbell, K.H.S. et al., 1996."Sheep cloned by nuclear transfer from a cultured cell line." *Nature*, vol. 380, pp. 64–67. The birth announcement of Dolly, a most famous cloned sheep.

Caskey, C. T. 1993. "Presymptomatic diagnosis: a first step toward genetic health care." *Science*, vol. 262, pp. 48–49. Identifying genes adds a new tool to medicine: the ability to predict disease.

CNN.Com/Health. August 28, 2001. "Researchers narrow search for longevity gene." www.cnn.com/ 001/HEALTH/08/27/longevity.genes/ index.html."... researchers have identified a region of a chromosome that they believe contains the genes responsible for longevity, according to a study published in a scientific journal."

Crick, F.H.C. et al., 1961. "General nature of the genetic code for proteins." *Nature*, vol. 192 pp. 1227–1232. Contrary to what headlines may say today, the genetic code was cracked in the 1960s— with some brilliant experiments.

Donis-Keller, Helen, et al., 1987. "A genetic linkage map of the human genome." *Cell*, vol 51, pp. 319–337. This landmark genetic map provided an initial scaffold for the human genome project.

Emery, Jon and Susan Hayflick. April 28, 2001. "The challenge of integrating genetic medicine into primary care." *British Medical Journal*, vol. 322, pp. 1027–1030. Doctors are returning to the classroom to keep up with the impact of genetics and genomics on the practice of medicine.

Friend, S. H. et al., 1988. "Oncogenes and tumor-suppressing genes." *The New England Journal of Medicine*, vol. 318, p. 618. At the cellular level, cancer is a genetic disease.

Galton, Francis. 1865. "Hereditary talent and character." *Macmillian's Magazine*, vol. 12, pp. 157–166. An early article from a major proponent of eugenics.

Gibbs, Nancy. February 19, 2001. "Baby, It's You! And You, and You..." *Time Magazine*, Vol. 157 No. 7, www.time.com/time/ health/artcle/ 0,8599,98998,00.html. "Renegade scientists say they are ready to start applying the technology of cloning to human beings."

Golden, Frederic. August 20, 2001. "Stem Winder: Before James Thomson came along, embryonic stem cells were a researcher's dream. Now they're a political hot potato." *Time Magazine*, Vol. 158 No. 7 Special Issue. www.cnn.com/ SPECIALS/2001/americasbest/science.medicine/ pro.jthomson.html. Scientist James Thomson discusses the future of embryonic stem cell research after President Bush's restriction on new cell lines.

Gusella, J.F. et al., 1983. "A polymorphic DNA marker genetically linked to Huntington's disease." *Nature*, vol. 238, pp. 234–238. Description of the first genetic marker.

Hall,Sarah. October 15, 2001. "Britain's first 'designer baby.'" *The Guardian*. www.guardian.co.uk/uk_news/story/0,3604,57421 1,00.html. "A British couple have sidestepped British regulations and undergone treatment in the US to ensure they give birth to a baby with an immune system which matches that of their son, who is recovering from leukaemia and may relapse."

Harper, P.S. et al., 2000. "Ten years of presymptomatic testing for Huntington's disease:

READINGS IN GENETICS AND GENOMICS

RICKI LEWIS

the experience of the United Kingdom Huntington's disease prediction consortium." *Journal of Medical Genetics*, vol. 37, pp. 567–571. Studies such as this one on reactions to tests for single gene disorders will be useful in guiding application of human genome information.

Hayflick, Leonard. January 27, 2000. "New approaches to old age." *Nature*, vol. 403, p. 365. Can we live longer than our genes dictate?

Huntington's Disease Collaborative Research Group. 1993. "A novel gene containing a trinucleotide repeat that is expanded and unstable on the Huntington disease chromosome." *Cell*, vol. 2, pp. 971–983. HD is one of a dozen disorders caused by an expanding gene.

Ingram, V. M. 1956. " A specific chemical difference between the globins of normal human and sickle cell anemia hemoglobin. *Nature,* vol. 178, p. 792. The classic paper that explains the molecular basis for sickle cell disease.

Kahney, Leander February 28, 2000. "Max Reincarnated." www.wired.com/news/technology/ 1,1282,34601,00.html. "A multi-million dollar research project to clone a billionaire's dog has spawned a gene bank that hopes to clone household pets."

Koshland, Daniel E. Jr. 1987. Sequencing the human genome. *Science*, vol. 236, p. 505. One of the first calls for a human genome project.

Lander, E. S. and D. Botstein. 1986. "Strategies for studying heterogeneous genetic traits in humans by using a linkage map of restriction fragment length polymorphisms." *Proceedings of the National Academy of Sciences*, vol. 83, pp. 7353–7357. A description of the technology used to construct the first human genome maps.

Lewis, Ricki. July 24, 2000. "Keeping up: Genetics to genomics in four editions." *The Scientist*, vol. 14, p. 46. A look at how genetics has morphed into genomics over the past decade.

McGee, Glenn, Ph.D. Febuary 10, "Becoming genomic: Just what does it mean anyway?"*MSNBC*, www.msnbc.com/news/529409.asp?cp1=1 This article mentions some of the ethical issues raised through Genomic research and offers links to resources and press coverage about Genomics.

Nature. February 15, 2001 issue devoted to the first draft sequence of the human genome.

McClintock, Barbara. 1950. "The origin and behavior of mutable loci in maize." *Proceedings of the National Academy of Sciences*, vol. 36,

pp. 344–355. Genetics is full of discoveries that at first do not fit existing knowledge. So it was for McClintock's discovery of "jumping genes."

Mendel, Gregor. March 1866. Experiments in plant hybridization. *The Journal of the Royal Horticultural Society*, pp. 3–47. Mendel's original paper is surprisingly clear and entertaining.

Meselson, M. and F. W. Stahl. 1958. "The replication of DNA in E. coli." *Proceedings of the National Academy of Sciences*, vol. 44, pp. 671–682. In a classic application of scientific inquiry, these experiments showed how DNA replicates— and how it does not.

Motulsky, A. G. "Michael Brown and Joseph Goldstein. 1986. The 1985 Nobel Prize in Physiology or Medicine." *Science*, vol. 231, pp. 126–129. The millions of people who take statin drugs today can thank Brown and Goldstein, and the one-in-a-million children with familial hypercholesterolemia who led them to understand how to control cholesterol metabolism.

Muller, H. J. 1922. "Variation due to change in the individual gene." *American Naturalist*, vol. 56, p. 32–50. Muller pioneered the idea of inducing mutations to studynormal gene function.

Nirenberg, M. W. and P. Leder. 1964. "RNA codewords and protein synthesis: The effect of trinucleotides upon the binding of mRNA to ribosomes. *Science*, vol. 145, pp. 1399–1407. By seeing which amino acids attached in the presence of which RNA triplets, these researchers and their colleagues deciphered the genetic code.

Science. February 16, 2001 issue devoted to the first draft sequence of the human genome.

Sturtevant, A. H. 1913. "The linear arrangement of six sex-linked factors in *Drosophila*, as shown by their mode of association." *Journal of Experimental Zoology*, vol. 14, pp. 43–59. The paper that laid the groundwork for all gene mapping.

Sutton, Walter S. 1903. "The chromosomes in heredity." *Biological Bulletin*, vol. 4, pp. 231–251. Sutton and Boveri independently established early in the twentieth century that chromosomes carry the units of heredity.

Trivedi, Bijal P. October 4, 2001. "ScientistsIdentify a Language Gene." *National Geographic Today*. http://news.nationalgeographic.com/news/2001/ 10/1004_TVlanguagegene.html. Researchers

in England identify FOXP2, the first gene to be linked to language and speech.

Venter, J.C. et al., February 16, 2001. "The sequence of the human genome." *Science*, vol. 291, p. 1204–1351. Celera Genomics' version of the human genome sequence.

Watson, James D. and F.H.C. Crick. April 25, 1953. Molecular structure of nucleic acids: A structure for deoxyribose nucleic acid. *Nature*, vol. 171, pp. 737–738. The original paper unveiling the structure of DNA.

Watson, James D. 1990. "The Human Genome Project: past, present, and future." *Science*, vol. 248, pp. 44–49. It's interesting to look back at the original game plan from the finish line.

Ye, X. et al., 2000. "Engineering the provitamin A (beta carotene) biosynthetic pathway into (carotenoid-free) rice endosperm." *Science*, vol. 287, pp. 303–305. While environmental extremists boycotted genetically modified foods, a group of researchers were quietly creating rice that manufactures its own vitamin A.

BOOKS

Davies, Kevin. 2001. *Cracking the Genome*. New York: Free Press. Sequencing the human genome was, at times, a vicious race.

Hamer, Dean and Peter Copeland. 1998. *Living with Our Genes*. New York: Doubleday. A readable and controversial account of behavioral genetics, by the discoverer of "gay" and "thrill-seeking" genes.

Henig, Robin Marantz.2000. *The Monk in the Garden: The Lost and Found Genius of Gregor Mendel, the Father of Genetics*. Boston: Houghton-Mifflin Co. A fascinating account of Mendel's life.

Hoagland, Mahlon. 1990. *Toward the Habit of Truth*. New York: W. W. Norton & Co. The story of the RNA tie club, whose esteemed members deciphered the genetic code—written by someone who was there.

Holtzman, Neil A. 1989. *Proceed with Caution, Predicting Genetic Risks in the Recombinant DNA Era*. Baltimore: Johns Hopkins University Press. Those seeking to apply human genome information would do well to consult this work on the ethical challenges that arose from knowing individual gene sequences—and even just markers that could predict high risk of inherited disease.

Kay, Lily E. 2001. *Who Wrote the Book of Life?*

Stanford, CA. Stanford University Press. The story of how a group of mostly physicists-turned-biologists deciphered the genetic code shortly after the structure of DNA was published.

Keller, Evelyn Fox. 2001. *The Century of the Gene*. Cambridge, MA: Harvard University Press. A look back and a look ahead, by an admired historian of science.

Lewis, Ricki. 2001. *Human Genetics: Concepts and Applications*. St. Louis: McGraw-Hill Higher Education. The basics of genetics and biotechnology.

National Research Council, 1988. *"Mapping and Sequencing the Human Genome."* Washington D.C.: National Academy Press. The original plans for the human genome project.

Orel, Vitezslav. 1996. *Gregor Mendel*. New York: Oxford University Press. A detailed biography of the insightful man who derived the basic laws of inheritance.

Ridley, Matt. 2000. *Genome: The Autobiography of a Species in 23 Chapters*. New York: HarperCollins. A chromosome by chromosome survey of the highlights of the human genome.

Watson, James D. 1968. *The Double Helix*. New York: New American Library. A personal account of the discovery of the structure of the hereditary material.

Wexler, Alice. 1995. *Mapping Fate*. New York: Random House, Inc. Before there were gene and genome discoveries, there were markers—and the pioneering pre-symptomatic tests that they spawned.

Wilmut, Ian. 2000. *The Second Creation: The Age of Biological Control by the Scientists That Cloned Dolly*. London: Headline Publishers. The story of Dolly, and clones who came before her.

RELATED WEB SITES

BIO: Biotechnology Industry Organization www.bio.org/ BIO represents biotechnology companies, academic institutions and state biotechnology centers. This site includes a large section on bioethics and biomedical research.

Genomic Art www.geneart.org/ A site devoted to visual artists and scientists exploring genetics and bioengineering, including the web site, *Paradise Now: Picturing the Genetic Revolution*, www.geneart.org/pn-intro.htm.

Pew Initiative on Food & Biotechnology
http://pewagbiotech.org/
"The Pew Initiative on Food and Biotechnology has
been established to be an independent and
objective source of credible information on
agricultural biotechnology for the public, media,
and policymakers." Includes helpful list
of links at pewagbiotech.org/resources/links/
andtheir newsletter, *The AgBiotech BUZZ* at
pewagbiotech.org/buzz/.

Science Functional Genomics
www.sciencemag.org/feature/plus/sfg/
A collection of resources related to the gene
sequence, its science, and its meaning... from
Science Magazine.

The Gene Media Forum
www.genemedia.org/.
"promotes public dialogue of genome research and
its impact on science and society. A non-profit,
non-partisan organization, it provides the
media with access to resources to help insure the
fullest coverage of the social and political,
as well as the science of the genetic revolution."

The Human GenomeProject
www.ornl.gov/hgmis/
A government sponsored site about the U.S. and
worldwide Human Genome Project.

The Roslin Institute
www.roslin.ac.uk/
The Roslin Institute website. The Scottish
institute is where researchers created
Dolly the sheep, the first clone of an adult mammal,
in 1997.

HEATHER ACKROYD & DAN HARVEY

Mother and Child, 2000
PHOTOSYNTHETIC "PHOTOGRAPH," CLAY, STAY-GREEN GRASS SEED, HUSSEIN, WATER, PROJECTOR
72 X 47
COURTESY OF THE ARTISTS, STAY-GREEN SEED DEVELOPED BY INGER UK

****ACTION TANK FOR ®™ARK**

BioTaylorism, 2000
MICROSOFT POWERPOINT PRESENTATION
COURTESY OF THE ARTISTS

120 CHECKLIST

SUZANNE ANKER

Zoosemiotics (Primates), 1993
MIXED MEDIA: GLASS VESSEL, STEEL, WATER, HYDROCAL, AND METALLIC PIGMENT
160 X 86 X 5
COURTESY OF UNIVERSAL CONCEPTS UNLIMITED

****DENNIS ASHBAUGH**

Bio-Gel (AKA The Jolly Green Giant) 1990–1991
MIXED MEDIA ON CANVAS
114 x 120
COURTESY OF THE ARTIST

****AZIZ + CUCHER**

Interior #5, 1999
CHROMOGENIC COLOR PHOTOGRAPH
50 X 72
COURTESY OF HENRY URBACH ARCHITECTURE, NEW YORK

****BRANDON BALLENGÉE**

Species Reclamation Via a Non-Linear Genetic Timeline; An Attempted Hymenochirus Curtipes Model Induced by Controlled Breeding, 2000
MIXED MEDIA: LIVE SPECIMENS, COMPUTER, DIGITAL PHOTOGRAPHS, AND PLASTIC TANKS
DIMENSIONS VARIABLE
COURTESY OF THE ARTIST

CHRISTINE BORLAND

HeLa, 2000
MIXED MEDIA: VIDEO MICROSCOPE, "HELA" CELLS, LCD MONITOR
21 X 64 X 22
COURTESY OF THE ARTIST, SEAN KELLY GALLERY, NEW YORK AND CARL ZEISS INC.

****NANCY BURSON AND DAVID KRAMLICH**

The Human Race Machine, 2000
COMPUTER SOFTWARE, HARDWARE, AND CABINET
64 X 24 X 48
COURTESY OF THE ARTISTS

****HELEN CHADWICK**

Nebula, 1996
COLOR CIBACHROME PHOTOGRAPHS MOUNTED IN PERSPEX PANELS
FOUR CIRCULAR PANELS 18 X 2; TWO CIRCULAR PANELS 23 X 2; ONE OVAL PANEL 35 X 2
COURTESY OF JGS, INC.

****KEVIN CLARKE**

Portrait of James D. Watson, 1998–1999
LIFOCHROME ARCHIVAL COLOR PRINTS UNDER ACRYLIC PANELS
SIX PANELS, APPROX. 29 X 96 EACH
COURTESY OF JGS, INC.

****KEITH COTTINGHAM**

Fictitious Portrait Series, 1993
CHROMOGENIC COLOR, DIGITALLY CONSTRUCTED PHOTOGRAPHS
THREE FRAMED PRINTS, 46 X 38 EACH
COURTESY OF RONALD FELDMAN FINE ARTS, NEW YORK

****BRYAN CROCKETT**

Ecco Homo Rattus, 2000
MARBLE AND EPOXY SCULPTURE
78 X 45 X 41
COURTESY OF JGS, INC.

***HANS DANUSER**

Frozen Embryo Series II, 1998–1999
PHOTOGRAPHS ON BARYTH PAPER, MOUNTED ON ALUMINUM
FOUR PANELS, 56 X 60 EACH
COURTESY OF JGS, INC.

****CHRISTINE DAVIS**

ACGT I and II, 1998–1999
ETCHED STEEL AND THREAD
67 X 31½ EACH
COURTESY OF THE ARTIST AND OLGA KORPER GALLERY, TORONTO

MARK DION

Daily Planet, 1991
OFFSET, LITHOGRAPHY ON NEWSPRINT
22 X 13¾
COURTESY OF THE ARTIST AND AMERICAN FINE ARTS, CO., NEW YORK

GEORGE GESSERT

Natural Selection, 1994–PRESENT
DYE SUBLIMATION PRINTS WITH TEXT
100 LOOSE LEAVES, 5¼ X 7¾ EACH
COURTESY OF THE ARTIST

REBECCA HOWLAND

The World in a Drop of Blood

Same Apartment, Different Tenant

Mr. And Mrs. Martin Scorsese

The Recipe of Me

A Hundred Sows and Bucks

Golden Goose

Eve and Adam

Double Twist

Regarding the Use of my DNA

Round Trip Ticket

Big Trouble Totally Fascinating

Hey Noble One!, 1999–2000
INK AND WATERCOLOR ON PAPER
TWELVE DRAWINGS, 11 X 17 EACH
COURTESY OF THE ARTIST

***NATALIE JAREMIJENKO**

Onetree, 2000
MIXED MEDIA INSTALLATION
DIMENSIONS VARIABLE
COURTESY OF THE ARTIST AND POSTMASTERS GALLERY, NEW YORK

RONALD JONES

Untitled (DNA Fragment from Human Chromosome 13 carrying Mutant Rb Genes also known as Malignant Oncogenes that trigger rapid Cancer Tumorigenesis), 1989
BRONZE (BLACK PATINA)
15½ X 68½
COURTESY OF RACHEL AND JEAN-PIERRE LEHMANN AND METRO PICTURES, NEW YORK

**EDUARDO KAC

Genesis**, 1999
MIXED MEDIA: LIVING
BACTERIA IN PETRI
DISH, PROJECTOR, AND
VINYL TEXT DNA
CONSULTATION AND
BACTERIAL CLONING:
CHARLES STROM, MD,
PHD; DNA MUSIC
SYNTHESIS: PETER GENA;
PROGRAMMING AND
ELECTRONICS: JON
FISHER; BIOLOGICAL
CONSULTATION AND TECH.
SUPPORT: RITA
CIURLIONIS; PROJECTS
MANAGEMENT: JULIA
FRIEDMAN AND
ASSOCIATES
DIMENSIONS VARIABLE
COURTESY OF THE ARTIST
AND JULIA FRIEDMAN
AND ASSOCIATES, CHICAGO

**DAVID KREMERS

Trophoblast**, 1992
GENETIC MATERIAL,
SYNTHETIC RESIN ON
ACRYLIC PLATE
24 X 24
COURTESY OF DILLON
COHEN, NEW YORK

**JANE LACKEY

smear (3)**, 2000
ACRYLIC, INK, CORK, BIRCH
44½ X 45 X 4
COURTESY OF JAMES
BERNSTEIN

*IÑIGO
MANGLANO-
OVALLE

Banks in Pink and
Blue**, 1999
LIQUID NITROGEN,
TANKS, HUMAN SEMEN,
FRAMED CONTRACTS
DIMENSIONS VARIABLE
COURTESY OF THE
ARTIST AND MAX
PROTETCH GALLERY,
NEW YORK

**JULIAN
LAVERDIERE

Transgenic Laureate**,
2000
MIXED MEDIA: ACRYLIC,
PVC, EURATHANE AGAR,
ALUMINUM, ELECTROLU-
MINESCENT WIRING,
VENTRICULAR FILM, AND
ULTRALIGHT POLYESTER
102 X 48 X 48
COURTESY OF A PRIVATE
COLLECTION, NEW YORK

KARL S. MIHAIL
AND
TRAN T.
KIM-TRANG

**The Creative Gene
Harvest Archive**, 1999
MIXED MEDIA: PLASTICS,
GLASS VIALS, HUMAN
HAIR, VINYL TEXT.
16 X 36 X 10
COURTESY OF THE
ARTISTS

FRANK MOORE

Oz, 2000
OIL ON CANVAS OVER
FEATHERBOARD PANEL
62 X 112
COURTESY OF JGS, INC.

**ALEXIS
ROCKMAN

The Farm** (2000)
OIL AND ACRYLIC ON
WOOD PANEL
96 X 120
COURTESY OF JGS, INC.

LARRY MILLER

**Genomic License No. 5
(Alison Knowles
Properties)**, 1992–97
CERTIFICATE AND
LICENSE FORMS,
DOCUMENTS, PHOTO-
GRAPHS, AUDIO
AND DNA SAMPLES.
84 X 96
BLACK AND WHITE
PHOTOGRAPH: PETER
MOORE, 1964;
COLOR PHOTOGRAPHS:
LARRY MILLER,
ART DIRECTOR AND
TRAVIS RUSE,
PHOTOGRAPHER
COURTESY OF EMILY
HARVEY

STEVE MILLER

**Genetic Portrait of
Isabel Goldsmith**, 1993
ACRYLIC AND
SILKSCREEN ENAMEL ON
CANVAS
96 X 48
COURTESY OF UNIVERSAL
CONCEPTS UNLIMITED

BRADLEY
RUBENSTEIN

Untitled (GIRL WITH
PUPPY-DOG EYES);
Untitled (GIRL WITH
PUPPY-DOG EYES);
Untitled (GIRL WITH
PUPPY-DOG EYES);
Untitled (BOY WITH
PUPPY-DOG EYES);
Untitled (GIRL WITH
PUPPY-DOG EYES), 1996
PHOTO-BASED WORKS,
LACQUER-BASED INK ON
RESIN-COATED PAPER
FIVE FRAMED PRINTS,
7 X 5 EACH
COURTESY OF UNIVERSAL
CONCEPTS UNLIMITED

**NICOLAS RULE

One Horse-Meadow
Star**, 1992
INK AND PENCIL ON
TRU-CORE
47 X 95
COURTESY OF JAMES
BERNSTEIN

CHRISTY RUPP

**New Labels for
Genetically
Engineered Food**,
1999–2000
IMPRINTED PLASTIC
CONTAINERS WITH VINYL
LABELS
INSTALLATION
DIMENSIONS VARIABLE
COURTESY OF THE
ARTIST AND FREDERIEKE
TAYLOR/TZ' ART
GALLERY, NEW YORK

GARY SCHNEIDER

**Tumor Suppressor
Gene (MLL) on
Chromosome 11 and
on the Nucleus**, 1997
TONED GELATIN SILVER
PRINTS
FOUR PRINTS, 29 X 31 EACH
COURTESY OF JGS, INC.
AND P.P.O.W., NEW YORK

LAURA STEIN

Smile Tomato, 1996
AND **Green Pig +
Smile on Vine**, 1998
CHROMOGENIC, COLOR
PHOTOGRAPHS
24 X 40 AND 30 X 40
(RESPECTIVELY)
COURTESY OF THE ARTIST

EVA SUTTON

Hybrids, 2000
INTERACTIVE PRINT WITH
SOUND
DIMENSIONS VARIABLE
COURTESY OF THE ARTIST

CATHERINE
WAGNER

**Minus –86 Degree
Freezers, (Twelve
Areas of Concern and
Crisis,)** 1995
GELATIN SILVER PRINTS
WITH VINYL TEXT
TWELVE FRAMED PRINTS,
24 X 20 EACH
COURTESY OF JGS, INC.

**CARRIE MAE
WEEMS

The Jefferson Suites**,
1999
DIGITAL PHOTOGRAPHS
ON MUSLIN WITH SOUND
DIMENSIONS VARIABLE
COURTESY OF
THE ARTIST, P.P.O.W.
GALLERY, NEW YORK,
AND JGS INC.

**GAIL WIGHT

Future Flight**, 2000
CHALKBOARD, WOOD,
AUDIO, VIDEO, DRAWINGS
78 X 72 X 24
DROSOPHILIA FOOTAGE,
COURTESY OF MICHAEL
DICKERSON AND
JOCELYN STAUNTON AT
THE DICKENSON LAB,
VLSB, UCB
COURTESY OF THE
ARTIST

**JANET ZWEIG
AND
LAURA BERGMAN

Abstraction Device,
(machine for finding
the earliest creativity
gene)** 2000
PAPER, METAL, MOTOR,
COMPUTER, PRINTER
DRAWING BY LAURA
BERGMAN
APPROX. 96 X 96 X 10
COURTESY OF JGS, INC.

121

The curators thank the participating artists, who were so generous with their ideas and their time, and: David Agus, M. D., Research Director, Prostate Cancer Center at Cedars-Sinai Medical Center; Joe Amrhein, Pierogi 2000, Brooklyn, New York; Charles J. Arntzen, President and CEO, Boyce Thompson Institute for Plant Research, Inc.; Bill Arning, Curator, List Visual Arts Center, Massachusetts Institute of Technology; Finley Austin, Assistant Director for Genomics Public Policy, Hoffmann-La Roche, Inc., Nutley, New Jersey; David Barre, Creative Manager, Greenpeace, Washington, D.C.; James Bell, SUSTAIN, Chicago; Maurice Berger;

nications, Incyte Genomics Inc.; Sanjiv Sam Gambhir, M.D., Ph.D., Associate Professor, UCLA School of Medicine; Alice George; Joy Glidden, Director, d.u.m.b.o. Arts Center, Brooklyn; Lisa Gloutney, Nexia Biotechnologies, Quebec; Jerilan Greene, Manager, Public Relations, Incyte Genomics, Inc.; Neal Gutterson, Managing Director of Research, DNA Plant Technology, Oakland; Paul Ha, Director White Columns; Holly Hinman, Assistant Curator, The New-York Historical Society; Jeff Hoone, Director, Light Works, Syracuse, New York; Susan Inglett; Jerry Jonas; Dwayne Kirk, Project Manager, Boyce Thompson Institute for Plant Research, Inc.; Billy Klüver; Noel Korten, Curatorial Director, Los Angeles Municipal Art Gallery; Thane Kreiner, Ph.D., Vice President, Business Operations and Public Affairs, Affymetrix, Santa Clara, California; Andrew Kreps; Jonathan Leiter, Program Director, The Joy of Giving Something, Inc.; Jane Marshing, Syracuse University, Syracuse, New York; Julie Martin; James Mayer; Daniel McDonald, American Fine Arts, New York; Alan McGowan, Co-Director, the Gene Media Forum, New York; Christina McAulifee, Cancer Center UMASS Medical School; Liz Merymen, Art Director, The Sciences, New York; Gerardo Mosquera, Adjunct Curator, New Museum, New York; Marc Nochella, Ronald Feldman Fine Arts, New York; Deb Ortman, Organic Consumer's

ACKNOWLEDGEMENTS

Brian Berk, Chief Financial Officer, Spot Design, New York; Peter Beyer, University of Freiburg; Marianne Boesky; Anne Bowdidge, Director, Industrial Relations, Affymetrix, Santa Clara, California; Josie Brown, Max Protetch Gallery, New York; Dan Cameron, Chief Curator, New Museum, New York; Mark Clements; Dillon Cohen; Dorit Cypis; Peter Dayton; Steve Dietz, Director of New Media Initiatives, Walker Arts Center, Minneapolis; Elliot Entis, President, Aqua Bounty Farms, Boston; Tom Finkelpearl, Program Director, P.S. 1 Contemporary Art Center, Long Island City, New York; Julia Friedman, Julia Friedman Associates, Chicago; David Friend; Teresa Gaines, Vice President Corporate Commu-

122

Association; Cécile Panzieri, Sean Kelly Gallery, New York; Janelle Porter, Artists Space, New York; Peter Quesenberry, Cancer Center UMASS Medical School; Kenneth Rabin, Chairman Global Healthcare, Burson-Marsteller, Washington, D.C.; Michael Read; Ed Ready, Zeneca Ag Products; Magdalena Sawon, Postmasters Gallery, New York; Chris Sims, Archivist, United States Holocaust Memorial Museum; Karen Sinsheimer, Curator of Photography, The Santa Barbara Museum of Art, Santa Barbara; James Christen Steward, Director, The University of Michigan Museum of Art; Wolf-Dieter Stoeffelmeier; Gloria Stone, Associate Director, Public Relations, Novartis Pharmaceuticals Corporation, East Hanover, New Jersey; Jeff Stryker; Akiko Takano, Director of International Programs, Gene Media Forum, New York; Frederieke Taylor, TZ'Art Gallery, New York; Irv Toplin, Carl Zeiss, Inc.; Janet A. Warrington, Ph.D., Director, Health Management, Applied Research, Affymetrix, Santa Clara, California; James D. Watson, Ph.D., President, Cold Spring Harbor Laboratory, Cold Spring Harbor, New York; Marshall Weinberg; Thair Witmer, Kansas Citizens for Science, Topeka; Marion Ziola, Universal Concepts Unlimited, New York.

At Exit Art, we would like to thank project coordinators Jodi Hanel and Edward Leffingwell; exhibition design, Constantin Boym, Boym Partners, New York; exhibition graphics, Drew Hodges and Lia Chee at Spot Design; public relations, Anne Edgar and Kelli Stauning; operations manager, Dennis Vermeulen, and interns, E. Kendall Younger and Vanessa Churchill. Thanks to co-founders/directors of Exit Art, Jeanette Ingberman and Papo Colo.

At the Tang Museum we would like to thank museum staff members: Ian Berry, Helaina Blume, Brian Caverly, Jill Cohan, Lori Geraghty, Ruth Greene-McNally, Allison Hunter, Susi Kerr, Gayle King, Chris Kobuskie, Gavin McKeirnan, Jennifer O'Shea, Barbara Rhoades, Barbara Schrade, and Charles Stainback. Also thanks to student intern, Harun Zankel, and installation crew, Tyler Auwarter, Jed Cleary, Abraham Ferraro, Shaw Fici, Steve Martonis, and Thaddeus Smith; Robert Kimmerle and Barbara Melville of College Relations; John Danison and John Sanders of the Center for Information Technology; Michael Casey and Mary Jo Driscoll of the Advancement office, Don Otterness, Rolling Edges Farm, Altamont; Bernard Possidente, Michael Marx, Susan Bender, Kate Leavitt, Karen Kellogg, Greg Pfitzer, Linda Simon, Ray Giguere, Terry Diggory, and the many faculty members that taught with *Paradise Now*. Thanks to catalogue designers: Barbara Glauber and Beverly Joel of Heavy Meta; and writers: Mike Fortun, Ricki Lewis, and Frank Moore.

This catalogue accompanies the exhibition

PARADISE NOW
PICTURING THE
GENETIC REVOLUTION

Exit Art
September 9 – October 28, 2000

The University of Michigan Museum of Art
March 17 – May 27, 2001

The Tang Museum, Skidmore College
September 15, 2001 – January 6, 2002

Paradise Now: Picturing the Genetic Revolution
originated at Exit Art in New York.
PROJECT COORDINATOR: Jodi Hanel and Edward
Leffingwell; EXHIBITION DESIGN: Constantin Boym,
Boym Partners, New York; EXHIBITION GRAPHICS:
Spot Design: Drew Hodges and Lia Chee;
INTERNS: E. Kendall Younger and Vanessa Churchill.
The presentation at Exit Art was made possible
through the generous support of the
Jerome Foundation, the Joy of Giving Something,
Inc., Roy and Nina Titus Foundation,
the New York State Council on the Arts and the
members of Exit Art.

The catalogue is published by The Tang Museum
at Skidmore College and was made
possible through the support of the Friends of Tang.

The Tang Teaching Museum and Art Gallery
Skidmore College
815 North Broadway
Saratoga Springs, New York 12866
T 518 580 8080
F 518 580 5069
www.skidmore.edu/tang

ISBN # 0-9708790-2-4

Library of Congress Control Number: 2001096294

Available through
D.A.P./Distributed Art Publishers
155 Sixth Avenue, 2nd Floor
New York, New York 10013
T 212 627 1999
F 212 627 9484

The videotape *Paradise Now: Picturing the
Genetic Revolution* was produced and directed by
Kathy Brew and Roberto Guerra and is
available through the Joy of Giving Something, Inc.,
e-mail jgs@genomicart.org
or call 212-472-2565.

The Tang Teaching Museum would like to thank
the artists, copyright holders and rights
holders of all images in this exhibition for granting
permission to reproduce their works in
this publication. Every effort has been made
to contact copyright holders prior to publication.

FRONT COVER
Heather Ackroyd and Dan Harvey
Mother and Child, 2000

BACK COVER
Frank Moore
Oz, 2000 (detail)

Photographs by David Allison and Arthur Evans
Designed by Barbara Glauber and Beverly Joel/
Heavy Meta
Edited by Ian Berry
Printed in Germany by Cantz

124